Visions
of a Huichol Shaman

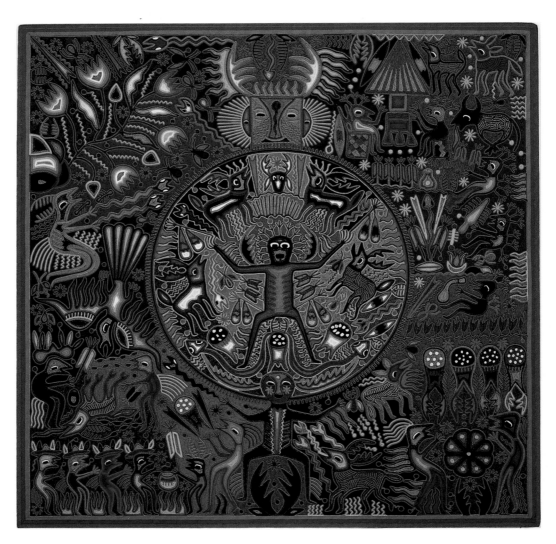

Frontispiece. Nieríka by José Benítez Sánchez. 2003-19-1. For a more complete description, see p. iv.

Visions
of a Huichol Shaman

Peter T. Furst

University of Pennsylvania Museum of Archaeology and Anthropology
Philadelphia

Copyright © 2003
University of Pennsylvania Museum of Archaeology and Anthropology
3260 South Street
Philadelphia, PA 19104

First Edition

Library of Congress Cataloging-in-Publication Data

Furst, Peter T.
 Visions of a Huichol shaman / Peter T. Furst.-- 1st ed.
 p. cm.
Includes bibliographical references and index.
 ISBN 1-931707-60-X (alk. paper)
 1. Benítez Sánchez, José, 1938- 2. Huichol art. 3. Huichol
mythology. 4. Huichol Indians--Religion. 5. Shamanism--Mexico. I.
Title.
F1221.H9 F87 2003
746.392--dc21
 2003010313

Frontispiece. In the central mandala of this nieríka, Benítez places a skeletonized shaman with his feathered power arrows held aloft. His flesh is ripped from his bones, leaving his spinal column and ribs exposed in x-ray style. Surrounding the mandala are deer, peyote, and rain serpents. A pair of shamans pound a drum at upper right. At lower right is the divine Mother of peyote and above her, four of her daughter plants, their roots ending in deer antlers. At upper left is the flowering *kiéri*, a plant from the deadly nightshade family that is half sorcerer, half teacher, and always the adversary of peyote. A party of *peyoteros* files across at bottom left, and everywhere there is evidence of transformation and the interconnectness of life. 48 in. by 48 in. 2003-19-1.

∞ Printed in Canada on acid-free paper.

Contents

Figures

Preface

Visions of a Huichol Shaman tells the remarkable story of the uniquely Huichol Indian yarn painting, from decorative folk art to one of the world's fine arts. It does so through the shaman-artist José Benítez Sánchez, whose well-earned fame rests on his creative ability to translate the most fleeting and sublime visions into two-dimensional form. These visions are of the Huichol world as it came into being in the First Times of creation and transformation and in the ongoing magic of a natural environment that is alive and without firm boundaries between the here and now and the ancestral past. All this is framed in the context of the history and present-day culture of his people.

The Huichols of the rugged Sierra Madre Occidental are unique among Mexico's indigenous peoples in that they alone have preserved their pre-European religion and rituals virtually intact. An impressive number of shamans see to it that the ancient myths and rituals continue to stay alive. Much Huichol art is devoted to communication with the numberless male and female ancestor and nature deities. It is in these sacred arts that the modern yarn painting has its roots. And it is in the visions of non-ordinary realities triggered by the visionary peyote cactus that painters in yarn like José Benítez Sánchez find their inspiration.

Peyote, which Native American Indian peoples have employed for the vision quests for at least 6,000 years, is not native to western Mexico or the mountainous Huichol homeland. Yet it is essential to Huichol spirituality and survival. and In order to gather it, every year small parties of Huichols travel 300 miles eastward to a sacred ancestral desert called Wirikúta. Here the pilgrims reenact a mythological ancestral hunt for a Sacred Deer that, when it fell dead from their arrows, gave birth to the sacred cactus.

To help us understand and unravel some of the complexities in Benítez's art, this book presents two important Huichol myths—the birth of the Sun God and the theft of Grandfather Fire from his underworld guardians.

This book shares with the reader the brilliant visionary works of Benítez, and through them something of the extraordinary Native American culture in which they originated. The University of Pennsylvania Museum of Archaeology and Anthropology has the good fortune to have acquired more than 30 of Benítez's extraordinary visual forays into the magical realms of creation and transformation that brought the Huichol world into being. *Visions of a Huichol Shaman* is intended to be a primary introduction into a uniquely Huichol art and the culture in which it has its roots. The chapters explain Huichol shamanism and traditional spirituality and relate the art to the visionary experience triggered by the complex chemistry of the divine peyote cactus.

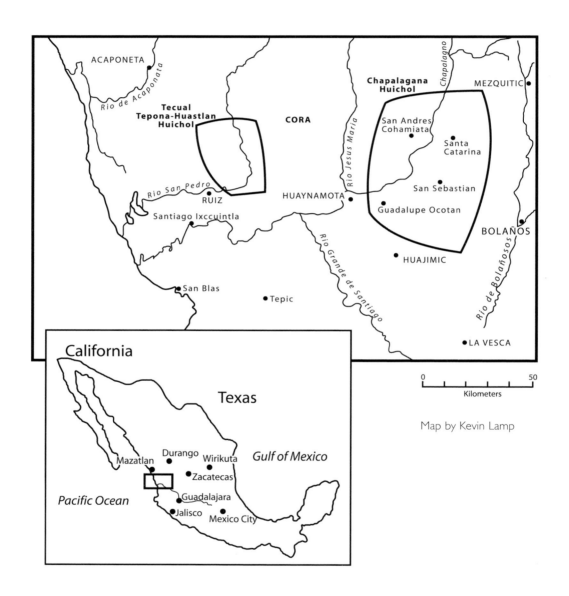

The Huichol Region

Acknowledgments

So many people have given me help and guidance in exploring the intellectual universe of the Mexican Indians known to the world as Huichols that to name them here would fill more than this page. So I will limit myself to those without whom this book, and the Museum's collection of masterpieces by the visionary shaman-artist José Benítez Sánchez, would not have come to fruition. My thanks go first of all to Pamela Hearne Jardine, then Assistant Director of the University of Pennsylvania Museum of Archaeology and Anthropology in charge of collections, who transmitted her infectious enthusiasm for Huichol art and culture to the Museum's director, the distinguished Maya archaeologist Jeremy Sabloff. He, in turn, immediately recognized the collection's potential for exhibition, study, and publication, and authorized its acquisition from the collector, Mark Lang.

In writing the book I had the good fortune of working with a museum staff both uniquely talented and helpful, as well as patient: Gillian Wakely, Associate Director for Programs; Walda Metcalf, Director of Publications; and Jennifer Quick, Senior Editor, who also applied her talents to the design of this book. To all and others within and outside the Museum who contributed in various ways, most especially Dr. Eugene Garfield, Editor-in-Chief of *The Scientist* and a long-time friend of Huichol art and artists, my sincere appreciation and thanks. Finally, grateful thanks are due to Roberta Hackel and Ernesto Ochóa.

All photographs in the book were taken by me unless otherwise indicated.

PETER T. FURST
Santa Fe, New Mexico
Spring 2003

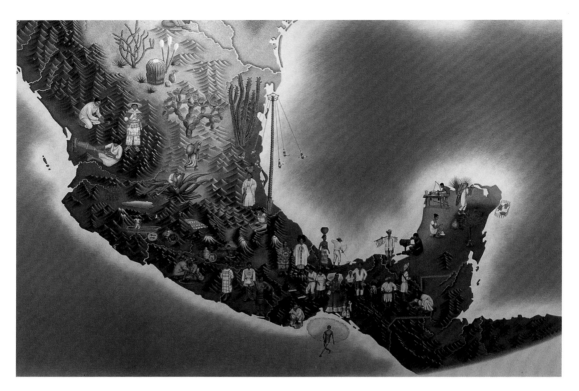

Fig. 1. Mural map of Mexico by Luis Covarrubias showing location of indigenous peoples; in the Museo Nacional de Antropología in Mexico City. The Huichol territory is at upper left.

Fig. 2. Detail in Luis Covarrubias's ethnographic mural of Mexico, showing the Huichol portion of the Sierra Madre Occidental. Museo Nacional de Antropología, Mexico City.

Visions of a Huichol Shaman

Religion is to them a personal matter; not an institution, and therefore their life is religious—from the cradle to the grave wrapped in symbolism.

Carl Lumholtz, *Symbolism of the Huichol Indians* (1900)

Several things immediately struck the Norwegian-born ethnographer Carl Lumholtz when he traveled among the Huichol, an indigenous people of the Sierra Madre Occidental (Figs. 1, 2), in the last decade of the 19th century. One was a powerful everyday spirituality that seemed to owe nothing to the religion of the *conquistadores*. Another was an extraordinary amount and variety of sacred art and symbolism. Every man and woman, and not a few children, were busy "making art" (Fig. 3) when not occupied with the chores of everyday life. Also, virtually all of the art on which they expended so much time and skill served a traditional religion with a crowded pantheon of male and female ancestor and nature deities and animating spirits of the natural environment, and with only a modicum of Christian admixture. Finally, there was an unusually high number of shamans, specialists in the sacred and diviners of the origins and cures of illness. With at least a third of adult men practicing a form of family shamanism, Lumholtz called this extraordinary people "a nation of doctors." He might as well have called them "a nation of artists."

Lumholtz chose Tuxpan de Bolaños, one of the several self-governing *comunidades indígenas* into which the Spanish colonial authorities had divided the Huichol territory in 1722. That was two centuries after Cortés and his combined forces of Spaniards and Indian allies had vanquished the mighty Aztecs. But it had taken that long for the native population of this part of the Sierra Madre Occidental to finally agree, however superficially, to Spanish military, ecclesiastical, and political control. Control was spotty, however: the Cora, neighbors and linguistic cousins of the Huichols, were rigidly supervised by the clergy, which outlawed all the old rituals and sacred art objects on pain of severe punishment. In contrast, the Huichols, particularly those near the Chapalagana River, were never really fully conquered, nor were they Christianized.

Lumholtz returned to New York and the American Museum of Natural History with a large collection of Huichol art and artifacts, and the material for two mono-

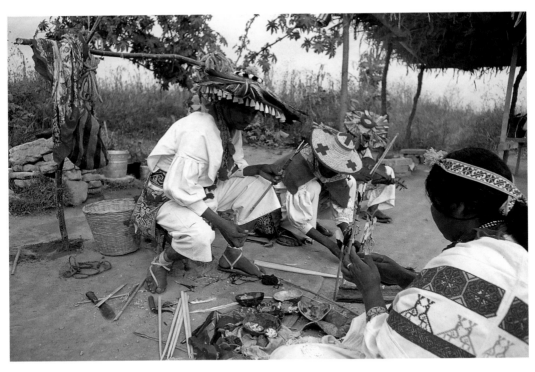

Fig. 3. The late shaman-artist Ramón Medina Silva (left), his wife Guadalupe de la Cruz Ríos (right foreground), and relatives preparing prayer offerings for a pilgrimage to Wirikúta, the sacred peyote desert in San Luis Potosí. December 1966.

graphs, *Symbolism of the Huichol Indians* (1900) and *Decorative Art of the Huichol Indians* (1904).

The distinction between "symbolic," meaning sacred, and "decorative" was somewhat artificial. There is a constant crossover between one and the other, just as there is between what people consider sacred and everyday or secular. The Huichols actually do not recognize a sharp dividing line: something or some action can be sacred in one context and not in another. Besides, the motifs with which women embellish their own and their husband's clothing are no less inspired than Lumholtz's "symbolism" by the sacred traditions passed down through the generations. We call these "myths," but Huichols treat them as their own sacred history.

More than a hundred years have gone by since Lumholtz's travels—a century of increased pressures for change, most profoundly experienced by the Huichol arts. Not the sacred arts and traditional symbolism, which remain in number and variety much as they were in Lumholtz's time. One would expect that, because the traditional religion of which they are a function and the high proportion of practicing shamans remain pretty much the same as well.

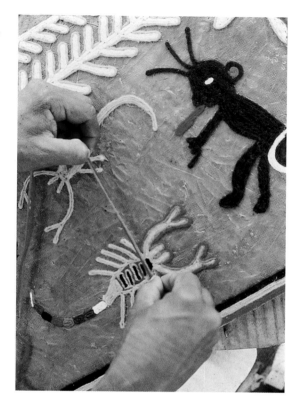

Fig. 4. For a yarn painting of the story of how the poisonous Centuroides scorpion came into the world, Ramón lays down colored yarn along a rough design scratched into a base of beeswax. Fowler Museum of Cultural History. July 1965.

What is new is a uniquely Huichol art form, the yarn painting, so called because in place of oils or watercolors the artist "paints" with multicolored yarns pressed into a thin base of beeswax (Figs. 4, 5). From simple, even crude, designs of yarn, the art of the yarn painting has become so inspired, so pleasing to the senses, so rich and complex in technique and content, indeed, so professional, that it can no longer be called folk art. In a very real sense, Huichol yarn paintings have entered the ranks of the so-called fine arts.

The art of yarn painting has its technological as well as inspirational roots in Huichol sacred art. That yarn paintings were from the start intended for the market has not detracted from the sacredness of their content and continuing role in Huichol devotional practice. Quite the contrary, the yarn painting has come full circle—from popular art to sacred: small yarn paintings with motifs taken from myth or nature are now sometimes included in the votive offerings people make for the deities.

On the larger scale, thanks to the creative genius of a handful of superbly trained and inspired Huichol interpreters of visions and mythology, masters of the craft like José Benítez Sánchez (Fig. 6), yarn paintings can now be found not only on the walls of museums of anthropology or popular arts, but in institutions and collections specializing in the fine arts.

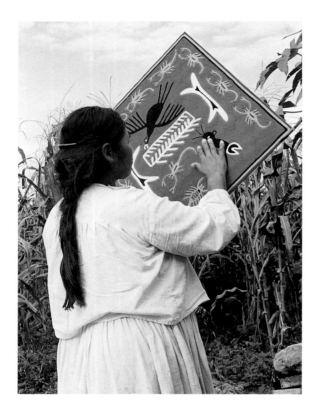

Fig. 5. Guadalupe prepares Ramón's yarn painting (24 in. by 24 in.) of the scorpion story for the UCLA Huichol collection. Fowler Museum of Cultural History. July 1965.

The Art of José Benítez Sánchez

In 1994, the University of Pennsylvania Museum of Archaeology and Anthropology had the great good fortune of acquiring a collection of Benítez's visionary yarn paintings. That they were technically flawless was not surprising: Benítez, now in his sixties, has practiced his art since his teens. He is not alone: there are perhaps a dozen artists, men and women both, who are, if not always his equals, not far behind. He stands out not just because of his superb workmanship and the fluidity, complexity, and aesthetic impact of his personal style, but also because he is a shaman.

As Lumholtz had discovered, a great many Huichol men, and also some women, have the knowledge to conduct rituals and divine the causes and cures of illness, and thus function as shamans at least on the level of the family. Before the introduction of antibiotics, infant mortality was 50 percent, so there was always a great demand for the shaman as doctor. It is better now, but still too high, a great tragedy because Huichols adore children and tend to spoil them. As Huichols say, there are simply no bad children, only bad parents—bad, because they haven't properly instructed their offspring (Figs. 7, 8). But artist-shamans occupy a special niche in Huichol culture and the larger world of popular art.

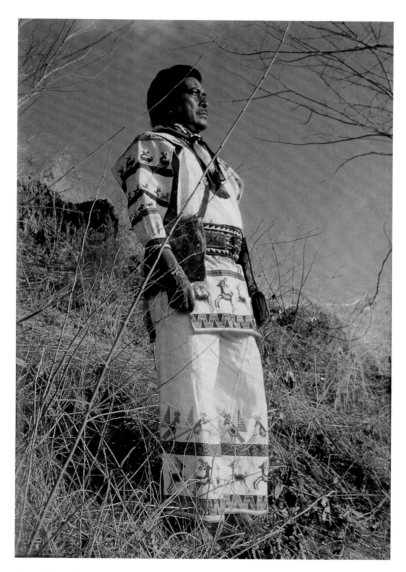

Fig. 6. The shaman-artist José Benítez Sánchez.

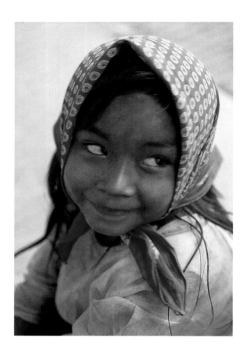

Fig. 7. Huichols dote on their children. If a child misbehaves, Huichols say it is the parents' fault for not teaching the child correctly. June 1969.

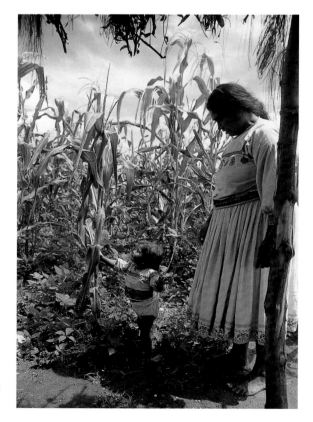

Fig. 8. The sacred maize is the mainstay of Huichol agriculture. It is sacred and children are taught its story and importance from an early age. Guadalupe with her and Ramón's adopted daughter 'Ulima on their *rancho* outside Guadalajara. Summer 1965.

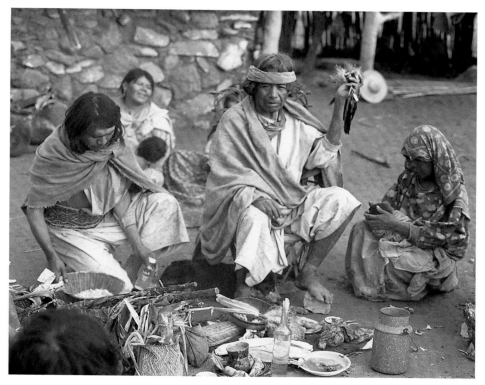

Fig. 9. The shaman Nicolas Carrillo de la Cruz (" 'Colas") conducting the "Ceremony of the Parched Maize" that follows the celebration of the safe return of the *peyoteros* from Wirikúta, the sacred peyote desert. 'Colas's *rancho*, San Andrés Cohamiata, in the Sierra Madre Occidental. March 1967.

 With so many practitioners of shamanism and shamanic healing, Lumholtz thought *Wixárika* (pl. *Wixáritari*), the Huichols' name for themselves, meant "doctors." While there is actually no convincing translation of this, it is still the case that the Huichols' indigenous neighbors credit them with much shamanic knowledge and power, and they often call on them for curing.

 One explanation for so many shamans lies in the widely dispersed settlement pattern. One *rancho*—the Huichol term is *kie* (house)—may be within sight of another, but visiting still requires many hours of hard walking and climbing. People always have need of healers and there is much ritual to be observed, on the family level as in the larger community. The solution is for as many individuals as possible to acquire the necessary knowledge and experience of the sacred to serve as shamans, at least for the needs of the family. In practice this means that the elder of most, if not every, *rancho* and *ranchería* is a shaman (Figs. 9, 10). Despite great demand on their time for ritual, divination, and curing, even the most prestigious shamans and political leaders—men of advanced age and great spiritual power, with reputations far beyond their own territorial community,

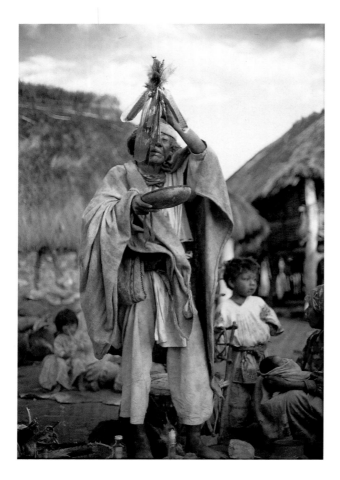

Fig. 10. Huichols feel all is well with the world if even one shaman helps the Sun God over the horizon and into the heavens. At dawn, 'Colas, the late great shaman of San Andrés Cohamiata, "raises" the Sun into the sky with his *muviéri*, the powerful shaman's feather bundle. March 1967.

like the late Nicolás Carrillo de la Cruz of San Andrés—participate in the everyday chores of family and community (Fig. 11).

Huichol shamans can be self-selected or called by such spirits as that of an ancestor who was a famous shaman. Also, shamanism tends to run in families. Benítez's father was a respected shaman, and so, if you asked other shamans you would find that their fathers and/or grandfathers were, too. Women shamans are rarer, but they do exist. In weaving, for example, a female art with a strong religious and symbolic component, learning to become a master weaver is qualitatively the same as becoming a shaman, requiring the same degree of spiritual commitment and esoteric knowledge (Fig. 12).

In learning to become a shaman there is no formal apprenticeship to an older experienced teacher. The novice makes a vow to "complete" himself and learns by listening and participating in the rituals. It can take the candidate years to absorb the enormous body of sacred stories and songs and techniques of shamanic curing. Shamans also acquire spirit helpers and animal allies. More than anything else, the

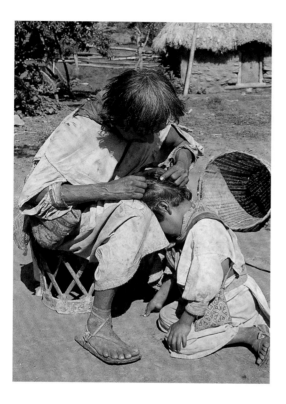

Fig. 11. Shamanism is never a full-time occupation, and even the most prestigious shamans must tend to the family's needs. 'Colas searching for head lice on one of his grandsons. San Andrés Cohamiata. Summer 1967.

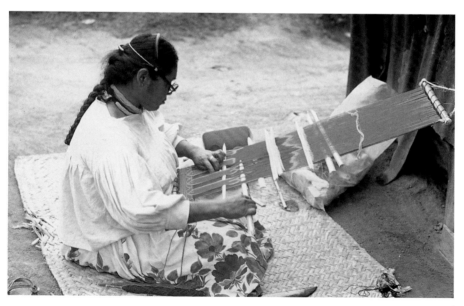

Fig. 12. Backstrap loom weaving is an ancient craft, with a rich symbolism that among Huichols ties it to peyote and shamanism. Guadalupe in her and Ramón's *rancho* outside Guadalajara. Summer 1965.

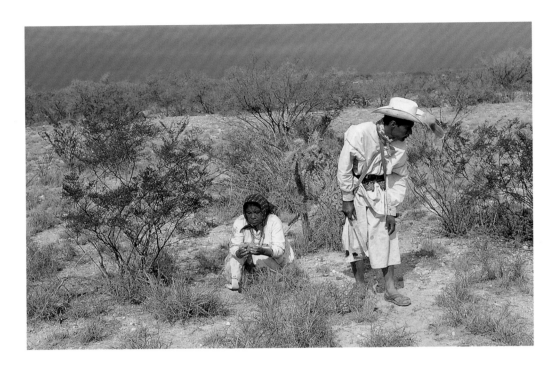

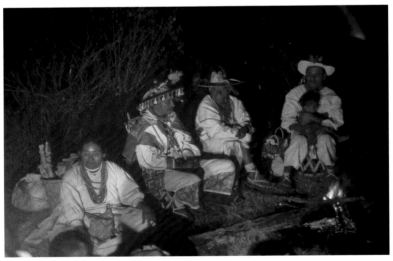

Fig. 13 (top). Searching for the elusive peyote in Wirikúta, the desert home of the sacred cactus and the ancestors. December 1968.

Fig. 14. Night is the time for reciting the myth of the first peyote hunt by Ramón Medina as leader of the *peyoteros* and stand-in for Tatewarí (Grandfather Fire), who led the divine ancestors to Wirikúta. Left foreground, Guadalupe de la Cruz Ríos. To Ramón's left, Guadalupe's uncle, the aged shaman José Ríos, veteran of more than thirty peyote pilgrimages. Wirikúta. December 1968.

future shaman must participate in at least five, and often considerably more, of the sacred pilgrimages to Wirikúta, the distant peyote desert in the state of San Luis Potosí (Figs. 13, 14). In Huichol sacred history, Wirikúta is the home of the Sacred Deer and the divine ancestors, near where the Sun Father was born from a now long-extinct volcano called Reu'unaxi, or, in Spanish, Cerro Quemado (Burned Mountain).

Distance from one family rancho to another is surely one explanation for the number of shamans. But there is another one at least as important, if not more so, something rare and remarkable in modern Mexico: of all the republic's indigenous inhabitants, and they number in the millions, the Huichols alone have successfully resisted all efforts at conversion. Although fundamental Protestantism has made some local inroads and Spanish Catholicism made some impression, however limited, the Huichols are thus alone in having preserved their traditional religion, their own spirituality in all its expressions, their own pantheon of ancestor and nature deities, along with a vast treasury of orally transmitted literary traditions, as we shall see in the Huichol origin myths.

Foreign ceremonies like Christmas and Holy Week based on the New Testament have added to but not replaced or changed the rich traditional ceremonial cycle. Nor have any of the aboriginal deities and nature spirits assumed new guises, as they have elsewhere in Indian Mexico. The Franciscans established some churches and missions, but priests have always been few and far between and are so today. Also, in some communities, San Andrés Cohamiata, for example, the 18th century Franciscan church has been co-opted for the Huichols' own ceremonial purposes, complete with a hole dug into the earthen floor for prayer offerings and to facilitate entry and exit for the gods (rather like the *sipapu* in Pueblo Indian *kivas*), while the Catholic images are left undisturbed or dressed up as Huichols (Figs. 15, 16).

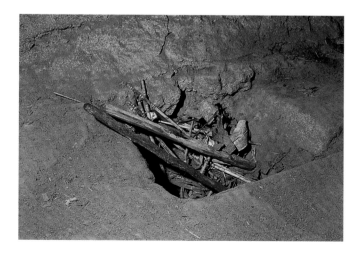

Fig. 15. Virtually co-opted by the Huichols for their own rituals, the 18th century Franciscan church at San Andrés Cohamiata even has a hole dug into its earthen floor for prayer arrows and passage by the aboriginal deities. Summer 1967.

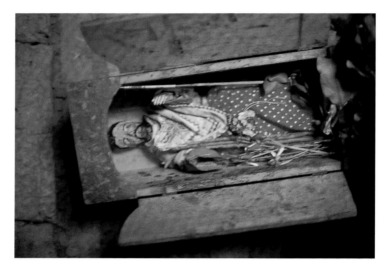

Fig. 16. With a woman's embroidered overblouse and printed skirt, Huichols have transformed this old bearded Catholic image in the Franciscan church at San Andrés Cohamiata into one of their own. March 1967.

Benítez's Story

In his visionary yarn paintings, Benítez moves back and forth between the realities we all experience and those that become visible only to the shaman. The Huichol cosmos consists of several levels: underworld, middle world, and upperworld. The upper and lower worlds are further subdivided into five lower levels and five upper. Shamans like Benítez can pierce these levels, and in his inspired art he takes us with him.

Over the years since Benítez achieved renown as one of the great modern Huichol artists, different versions of his life story have circulated in western Mexico, where he makes his home. Of these one has been published in his own words, which gives it a greater ring of truth. The translation is by Mark Lang, a long-time friend and collector of his work:

> I was born in San Pablo, in the municipality of El Nayar, at one in the morning on Friday, August 17, 1938. I was raised by my father and grandfather. My father is from Santa Gertrudis, a small rancho in San Sebastián Teponahuaxtlan, my mother from Santa Catarina Cuexcomatitan. That is where my eyes were opened, to be able to really see the world, and also where I was taught to work. My father was a famous *mara'akáme* [shaman]. The local communities kept him busy.

Once my father and I were traveling together and I said to him, "Look, there is a little rattlesnake."

It was a tiny, tiny rattlesnake. It was very tender, very clear, very bright, like the [yellow] root paint we use in Reál de Catorce [Wirikúta]. And he said, "Take it, get its heart and eat it. If you don't want to grab it, I'll do it."

My father grabbed it and sliced it open and gave it to me to suck the blood. And I swallowed the heart. Then he cut off a bit of the tail and he painted (with the blood) two small lines here on my cheek on the right side, then here on the shin and then on the foot. That's about when it all started.

When I was about fifteen years old I stayed with a godfather called Pedro Rodriguez. He gave me food and there I worked with him. I got sick on one foot. It got all bloated, and a Cora mara'akáme told me, "Look, you are sick because you turned your back on your culture. You failed it. The gods are punishing you." As soon as I got over the sickness, I returned home. I told my father that a Cora healer had told me I was sick because of the [ritual] obligations I had here at home with the serpents and the sacred places.

"Well," he said, "what we can do is have you start chasing deer in September. If you kill a deer we'll go to Reál de Catorce."

I went hunting and caught a deer with a net, a deer and a doe. I said to my father, "Look, here they are so now we can go to Wirikúta."

"That's good, we will go and on returning we will do the Festival of the Drum."

We didn't go, and I was getting disappointed. I said, "Look father, if you are not going I am going by myself, whatever it takes. I made a promise and that promise must be kept." I left with a [peyote] pilgrim who lived at El Naranjo. It took us about twenty days.

When I returned my father asked, "Where were you?" I told him I went on the trip and brought back a bag of peyote. So I prepared a setting for my mother and father. I split six peyotes very nicely into slices. That is when he started to tell me about the paintings, when I gave him the peyote.

He said, "When you go over there [to Wirikúta], you must take a gourd bowl, an arrow, a candle, and in a very small painting you have to make yourself, a small deer, a snake, and your sister and us, so that you have good thoughts and visions in the desert."

So then I started thinking, "Next year I am going to do what he told me."

And I did not forget. I recorded it in my thoughts. The next year I left with others. So I went with them for the next six years and I took the [yarn] paintings as I was told by my Father. I made them out of lamb's wool.

When the Instituto Nacional Indigenista office was created here in Tepic [capital of the state of Nayarit], I swept floors. Then I was given a job purchasing handicrafts for the INI—bags, yarn paintings, round woven nieríkas, hats, everything. Then I wondered, "Will my paintings sell?"

Fig. 17. The prominent Mexican anthropologist Salomón Nahmad Sittón (right) and the shaman-artist Ramón Medina Silva (Huichol name: 'Uru Temay, Young Arrow Person or Newly Made Arrow) on the peyote pilgrimage to Wirikúta. December 1968.

Then the professor called me, an anthropologist who was the director of the INI in Tepic, Salomón Nahmad [Fig. 17]. He said to me, "Benítez, why don't you make some paintings, some *ojos de dios* ["god' eyes"]. Let's see what you can do. We buy these."

I asked, "Do you want whatever comes out?"

"Whatever comes out," he said.

I already had some and I made more. What I drew primarily were the deer, the snake, my sister, things resembling where I lived.

That's how I got started. Two days later I took them to Salomón Nahmad. He said, "That's nice. Make some more. Look for other memories. Do you have some more memories?"

I said I had many more memories. I never duplicate my paintings and so I had used up only one idea, but I already had some more ideas from the paintings I had been carrying for six years [to Wirikúta].

That Benítez traces his reentry into traditional Huichol culture and his own path to shamanism back to an illness is interesting. "Sickness vocation" happens to be a virtually universal phenomenon: the future shaman is "called" through an illness that usually requires the ministrations of an experienced shamanic healer and a commitment to shamanic practice. Rejecting such a call from the spirits might even result in death. As a boy the late shaman-artist Ramón Medina suffered the bite of a poisonous coral snake on the shin that almost killed him and for many weeks virtually paralyzed him from the waist down. He was eventually cured by his paternal shaman grandfather, but in return had to pledge to "complete" himself as a shaman

to Grandfather Fire and Father Sun. The literature on shamanism is full of similar examples.

The story of Benítez's early life and career as an artist appeared in 1994 in *Aguamilpas, Ojo del Luz en el Territorio Mágico*. *Aguamilpas* (*agua*=water, *milpas*=maize fields) is the name of a hydroelectric dam the government constructed a few years ago on the lower Lerma river in the rural colony settled in the 1920s and 1930s by Huichols who fled the violence of the so-called Cristero Rebellion. This armed uprising against the government's secularization of schools, confiscation of the vast lands owned by the Church, and the persecution of priests started in the lowlands but also engulfed parts of the Huichol territory in the Sierra Madre Occidental. Internecine warfare and land invasions by non-Indians virtually depopulated some communities, especially San Sebastián Teponahuaxtlan, the birthplace of Benítez's shaman father.

The *territorio mágico,* the magical land or land of magic, is the romantic view of at least the mental if not the physical environment in which Huichols make their lives. While it obscures their very real problems, there is at least this kernel of truth: for Huichols the natural environment is alive and so in a sense "magical," in that every phenomenon—from mountains, deer, foxes, birds, rain clouds, rivers, woods, and cultivated fields to every flower, bush, spring, or rock, down to clumps of grass, lizards, or insects—is imbued with a conscious life force, or soul. Hence, Huichols could not imagine what is meant by "inanimate." Nor would the term "supernatural" make sense to people for whom divinity is inherent *in* nature, not above it, as is implied by the *super* in "supernatural." It is this mental universe in which Benítez operates, as artist and as shaman, even as he is very much a participant in a market society.

The account of his early life in *Aguamilpas* ends with just the faintest beginnings of his career in art and the shamanic world view. It thus leaves out a good deal. Benítez owes at least some of his success in the 1970s to an association with Juan Negrín, a Spanish-born student of Huichol culture who early on saw Benítez's promise and arranged for public exhibitions. There was also his apprenticeship in the 1960s to an experienced and highly successful yarn painter, his cousin Ramón Medina Silva, who greatly improved his technique and his resort to Huichol mythology for inspiration. The multi-talented Ramón, who himself "completed" as a shaman in 1968, on the fifth of the five peyote pilgrimages to Wirikúta he had pledged as a youth to his divine patrons, Fire and Sun, had three years earlier turned the art of yarn painting in a new direction, when he began using it to illustrate texts from his own impressive inventory of Huichol mythology.

Of this important development more later; what counts here is that unlike Ramón, who prior to the summer of 1965 had considerable success with decorative yarn paintings that used Huichol motifs but otherwise had no special significance, Benítez was able to jump right into this new tradition of two-dimensional narrative and visionary art.

For Benítez, the dual road of becoming a shaman and visionary artist was his way of reentering and committing himself fully to Huichol spiritual culture. Not only was

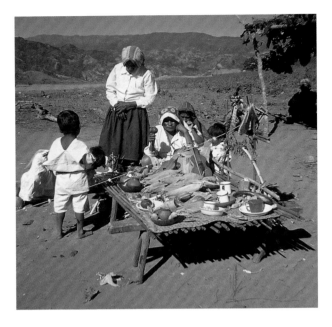

Fig. 18. In the Ceremony of "Our Mother the Drum" (called "First Fruits" by Lumholtz), children represent the new maize and squash and, magically transformed into little birds in the officiating shaman's song, "fly" to Wirikúta to learn the route of the ancestral *peyoteros*. Rancho El Colorín, in the Huichol rural colony on the lower Río Lerma. 1971. Photo by Marina Anguiano.

this commitment for himself, it also affected other Huichols in the Lower Rio Lerma settlement who managed to preserve family rituals but otherwise had been floating between two worlds (Fig. 18).

What had limited their full participation in Huichol spirituality was the lack of the traditional community temple, called *tuki* (great house) or *calihuey* (from the Nahuatl *huey calli*, likewise meaning 'great house') (Fig. 19). Most Huichol ranchos include a small family temple or oratory (*xiriki*) dedicated to one or more of the deities or, more often, an

Fig. 19. The circular aboriginal temple (*tuki*) at San Andrés Cohamiata, Sierra Madre Occidental, flanked by a subordinate oratory (*xiriki*) dedicated to an individual deity. Summer 1967.

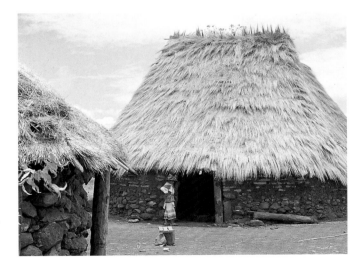

Fig. 20. The new urban Huichol *comunidad indígena* of Tsitákua in Tepic, Nayarit, is topped by an old shrine of large carved boulders of Precolumbian origin. Huichols believe the largest (at right) represents their own Great-grandmother Nakawé, the aged earth and creator goddess. Summer 1996.

ancestor whose soul is manifested in a small rock crystal in the shaman's care. But it is the large temple, the tuki, that embodies the community as a whole. Its circular architecture and complex symbolism encapsulate the cosmos. Among other purposes it serves to observe the movements and the meeting of sun and moon and both expresses and reinforces social and spiritual cohesion and the community's connection with the sacred. Though he did not himself live there, Benítez stepped into this void, using his own substantial income from his art to give the community its missing temple.

It was also his growing fame and his friendship with Celso Delgado, governor of the state of Nayarit from 1987 to 1993, that led to the establishment of Tsitákua, a hillside settlement of some 500 Huichols overlooking Tepic, the state capital, as the first self-governing *comunidad indígena* outside the Huichol home territory. It caused quite a stir—local real estate interests and developers had long had their eye on this desirable piece of property, and now here was the governor giving it away to "a bunch of Indians"!

Benítez built himself a house in Tsitákua on a street named for Great-grandmother Nakawé, the aged, white-haired creator goddess and divine patron of the new community (Fig. 20), and became its first elected governor. The Huichol term for this highly respected functionary, whose word is virtual law during his year in office, is *tatoani*, from *tlaoani*, "one who speaks well." This was the Nahuatl honorific which the Aztecs

17

used for their emperor and which came into the Sierra with Spanish colonial control in 1722. As he had already done for the Río Lerma colony, Benítez also financed the construction of the new community's own circular temple.

The Magic of Wirikúta and Peyote

The most magical Huichol territory of all is surely Wirikúta, the land of the divine visionary peyote, where Benítez carried his first miniature yarn painting as an offering to the peyote and the divine ancestors.

The English and Spanish word "peyote" comes from the Nahuatl (Aztec) *peyotl*. The Huichols call it *híkuri*, as do the Rarámuri (Tarahumara), who live in the northern state of Chihuahua. To the botanist it is *Lophophora williamsii* (Fig. 21). With more than thirty active alkaloids, led by mescaline, it has been rightly called a "veritable factory of alkaloids." Mescaline was recognized already in the 19th century, but it owes its fame for its amazing effects on consciousness to Aldous Huxley's *The Doors to Perception* (1954). Huichols of course credit its power to godliness rather than chemistry. For them the little cactus is a manifestation of ongoing processes of transformation and the qualitative equivalence of what to us would seem like incompatible life forms. Hence there is much more to peyote for them than only the wondrous effects of its alkaloids.

That it is so very sacred to Huichols may in part explain why they regard it as an especially effective medicine, almost a panacea. While they may not understand its complex chemistry, their faith in its healing power was vindicated in 1960, when modern chemistry discovered among its many constituents several antibiotics that prevent and cure external and internal infections.

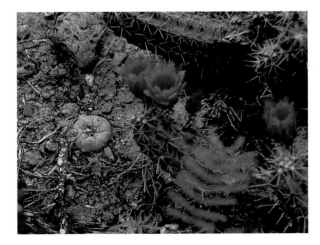

Fig. 21. Peyote is often protected against predation by deer or rabbits by the sharp spines of cactus or mesquite. Lower Río Grande valley, Texas. Winter 1992.

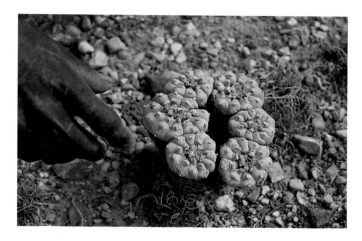

Fig. 22. The Huichols customarily promote new growth by leaving a piece of the peyote root in the ground. Multiples of the sacred cactus that grew, as here, from a single root are treated with special reverence. 1968 peyote pilmagrage.

Peyote is found over a large part of the north-central Mexican desert and the lower Río Grande valley. But for Huichols the only peyote that matters is that for which they search in Wirikúta at the end of their 300-mile quest from western Mexico (Fig. 22). Wirikúta, which some Huichols say means "In back of the [divine] Mother of Peyote" (Fig. 23), cannot be found under that name on the map. Yet it is both a physical locale in the geography of arid north-central Mexico and a place of dream, myth, and vision.

As Benítez does in his autobiography, Wirikúta is sometimes referred to as Reál de Catorce, an old Spanish colonial silver mining district in the state of San Luis Potosí with which it overlaps.

Fig. 23. Peyote bag by Guadalupe de la Cruz Ríos, one of her last embroideries before her death in 1998 in her nineties. The divine Mother of the sacred cactus appears in the upper right in light green.

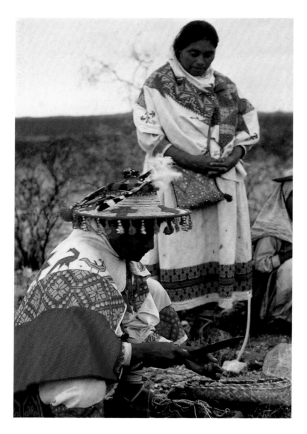

Fig. 24. With Lupe in reverent contemplation, Ramón Medina slices peyote for sacramental distribution to his fellow *peyoteros*. Wirikúta, San Luis Potosí. December 1968.

What *catorce* (fourteen) refers to is something of a mystery, one theory being that it is named for fourteen Spaniards, perhaps prospectors, killed by local Indians to avoid being enslaved. This would not be surprising, because Indian people were regularly kidnapped and forced into the silver mines, where countless numbers died of overwork, disease, and starvation.

The Hunt for the Divine Cactus

For Huichols Wirikúta is so permeated with the sacred that it cannot be anything but "beautiful," no matter that it is a typical arid Chihuahuan desert that seems to spring into life only with the coming of the rains. One Huichol name for Wirikúta is "dancing patio" of the divine ancestors, and when they hold their own dances there, they invite

the people "down below" to join them by slapping the desert floor as hard as they can with their sandals.

Wirikúta is the abode not only of these ancestral divinities, but of the Sacred Deer. It is also the ultimate destination of souls of the dead. The maize goddess, Our Mother Niwétsika, has her rancho here and so does the culture hero, onetime trickster, and deer god Káuyumari. Wirikúta is embedded in what Huichols call the *iyári* (soul- or heart-memory), which resides in the center of the chest and is thought to be the home of a kind of collective memory of the totality of "being Huichol." No wonder that when Huichols go on the peyote pilgrimage, they say it is "to find our life."

Every year small parties of Huichols make this difficult, physically and emotional-ly demanding trek to "hunt" peyote. In the old days they walked all the way, twenty days there and twenty days back. Sometimes they still go on foot, but more often the *peyoteros* make use of whatever transport is available. Some of the plants they harvest are sliced and consumed on the spot as a kind of Holy Communion meal. Large quantities are carried back for the ceremonies, to be kept fresh temporarily in small plantings close to the houses (Figs. 24, 25). "Hunt" is no exaggeration: Huichols "track" peyote just as if it were deer. Not any deer, of course, but the Sacred Deer of the peyote origin myth.

In this lengthy oral tradition, which the shaman sings in the ceremonies, the ancestral hunters were tracking a beautiful Virginia or white-tailed deer that vanished and reappeared as though to tease them. To please the sacred animal and coax it into

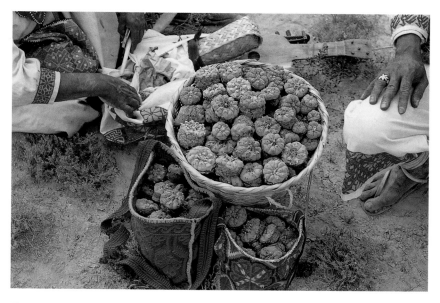

Fig. 25. *Peyoteros* fill shoulder bags and burden baskets with peyote for ceremo-nial use at home. Wirikúta, San Luis Potosí. December 1968.

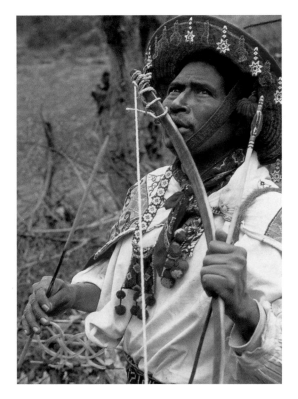

Fig. 26. The Huichols are among the few peoples in the world to use the hunting bow and arrow as a percussion instrument, which they call "bow drum." On the hunt the surprisingly melodic sound is meant to "charm" the deer (the peyote) so that it does not "try to run away." Wirikúta. December 1968.

standing still, one of the ancestors used his hunting bow as a musical instrument. Huichols call this the "bow drum" (Fig. 26). Oddly enough, they share this evidently very ancient and surprisingly melodic use of the bow with a very few other indigenous hunting peoples in South America and Africa. When the magical deer finally allowed itself to be seen, they killed it with their arrows. At the moment of its sacrificial death, peyotes sprouted from its antlers, hooves, and body (Fig. 27). Hungry and thirsty as they were, they tasted the peyote and found themselves in a world utterly transformed and bathed in beautiful, shimmering colors.

Each year Huichols peyoteros reenact this magical hunt by shooting arrows at the first peyote to reveal itself (Fig. 28). Because the first hunters were themselves the ancestor gods, their modern successors assume their identities, becoming their own divine progenitors, much as Hopi Indians in Arizona become the kachinas whose costumes and accouterments they don.

The deer that is peyote has other personalities as well. It is the culture hero Káuyumari (the Deer Person) who gave the ancestors their rituals and sacred paraphernalia but also the first death, and whose heart is peyote, even as he himself is both peyote and deer. He serves as chief assistant to Tatewarí (Our Grandfather), the aged fire god who is also the divine patron of human shamans. Tatewarí and Káuyumari together guide

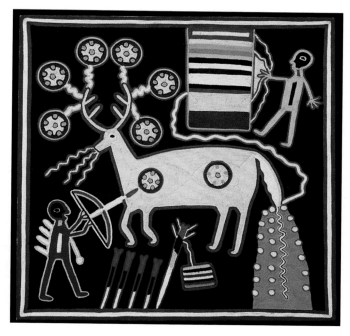

Fig. 27. A 1995 yarn painting by Chavelo Gonzalez of peyote plants sprouting from the antlers and body of the divine deer. The artist, who continues to follow Ramón Medina's 1960s style, is one of Guadalupe's relatives by marriage. 24 in. by 24 in. Author's collection.

the souls of the deceased to their final abode. Some, if they are shamans, pass into the company of the Sun God on his travels through sky and underworld, others to the village of the dead in the underworld, and finally, to Wirikúta, the land of the peyote.

Because he is so many things at once, for the student of Huichol culture Káuyumari is the most difficult and complex of all the divine beings to understand. This is the more true in that he is also that primordial pan-Indian personality, the Trickster, whose pranks, like those of Coyote, his California Indian counterpart, or Raven on the Northwest Coast, more often than not backfired on himself. Huichols simply accept the two sides as complementary.

The divine deer of the peyote myth is not only Káuyumari but merges also with one of the most important of the male deities of the dry season—the deer god Great-grandfather (or, sometimes, Elder Brother) Deer Tail, Máxa Kwaxí in Huichol. All the gods are shamans and transformers. But Deer Tail is the only one of the gods who may have had a human prototype in a charismatic shaman chief who bore the same name and who at some unknown time in the past led his followers out of the Wirikúta desert westward into the Sierra Madre Occidental. As tradition has it, here he converted the

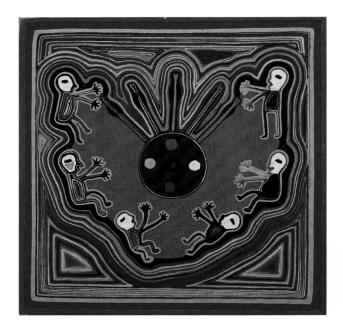

Fig. 28. A visionary nieríka by Ramón Medina of the veneration of peyote in Wirikúta. The arrows at top are those with which he "slew" the potent little cactus in a reenactment of the first hunt of the deer that was peyote by the ancestors. 24 in. by 24 in. Fowler Museum of Cultural History.

Fig. 29. A commemorative bundle rich with offerings of prayer arrows and "eyes of god." Collected by the German ethnologist Konrad Theodor Preuss in 1907, it represents the deer god Great-grandfather Deer Tail seated in a miniature shaman's chair. The remains of a real-life shaman leader with that name are believed to be hidden in a sacred canyon in Huichol country. H. 28-1/4 in. Preuss Archive, Museum für Völkerkunde, Berlin-Dahlem.

local people to his own peyote-centered religion, founded a confederation of several Indian nations, and at death became transmogrified into a god (Fig. 29). If there is historical truth to this old tradition, he and his people may well have been among the ancestors of the present-day Huichols.

Art for the Gods

The different kinds of art Lumholtz saw Huichols make were almost exclusively devoted to communication with a crowded pantheon of male and female ancestor and nature deities. People say, only half-jokingly, that there are as many gods as there are Huichols. The deities are addressed or spoken of by ritual kinship terms: Great-grand-

mother, Grandfather, Elder Brother, Mother, and so forth, always preceded by *Ta*, 'Our.' The rain goddesses, each addressed as Our Mother, are of particular importance, and there is one or more for each of the cardinal directions and the cosmic center. In art they appear as snakes. The Sun God is Our Father, or Tawerikúa (Our Eagle). This may or may not reflect the Aztecs' identification of the divine Sun with the Eagle, although what Huichols call eagle is more often than not the red-tailed hawk. In the myth of the Sun Father's birth (see below) he is also called Táu, from the sound made by Turkey Person when the Sun first appeared in the world. In commemoration of this christening in myth time, veteran peyoteros are entitled to decorate their hats with turkey feathers (Fig. 30).

The Divine Deer

Many animals are sacred, but the most sacred of all is the white-tailed or Virginia deer. Deer have become scarce in and around the Huichol country since the introduction of the rifle, so much so that bulls are now sacrificed in their place. Nevertheless, the communal hunt for deer remains one of the most important events in the ritual cycle, and when it meets with success, the slain animal is treated with great reverence, laid out on an embroidered cloth, its thirst slaked with sacred water and its hunger stilled with its favorite grasses. It is of course eaten, a favorite form being venison soup, but being sacred and having all these symbolic associations, it is never treated or thought of as just a source of protein.

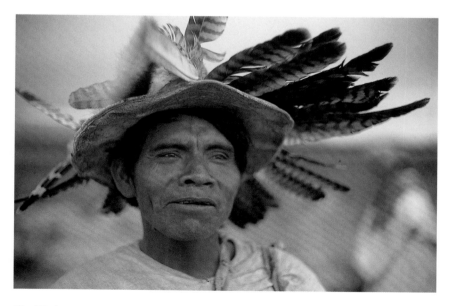

Fig. 30. A veteran *peyotero* with his turkey feather hat. Wirikúta. December 1968.

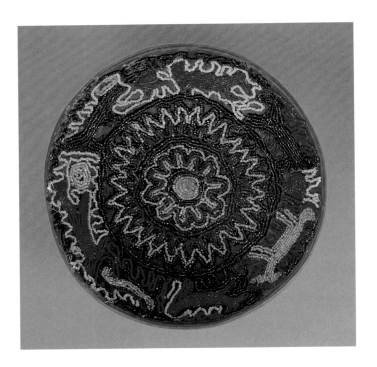

Figs. 31, 32. A pair of richly decorated votive gourd bowls made for the anthropologist Robert M. Zingg in 1934; in the Huichol collection of the University of Pennsylvania Museum of Archaeology and Anthropology. Above: 38-23-122. Right: 38-23-123. Dia. of both 8-1/4 in.

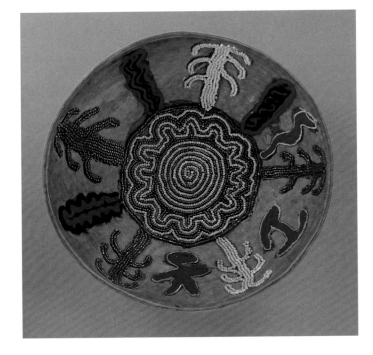

In myth and thought there are deer of different colors: white deer of daylight, dark deer of night, red deer of noontime, with especially great importance and much symbolism attached to deer of the color blue. In art, especially that of Benítez, deer antlers identify the sacred and thus play the same role as the halo does in Renaissance paintings. This is why in Benítez's yarn paintings one sees antlers not just on deer but other species not so adorned in nature, along with people, plants, fire, water, rain serpents, and features of the environment.

And if his works literally pulsate with life, and if figures, foreground, and background seem to transform before your eyes or melt into one another without distinctive boundaries, it is because especially in the mythic First Times and in Wirikúta the real-life environment is not only alive but capable of instant shape-shifting.

But that is the function of art, or one of its functions—to keep the higher powers happy and well disposed toward the people.

The Votive Gourd Bowl

At least since the time of Lumholtz, but probably long before, among the most beautiful objects of art dedicated to the deities by the Huichols have been gourd bowls decorated on the interior walls with symbols of their hopes and wishes in yarn and/or glass beads pressed into wax (Figs. 31, 32). Called *xukúri*, the decorated votive gourd bowl was, and still is, considered the most effective means of communication with the divine. The word itself is closely related to, and perhaps derives from, *xicolli*, the Aztec word for calabash, bowl, or cup. As visual metaphors for the life-giving womb the Huichol votive gourds are consecrated especially to the divine Mothers, the goddesses in charge of rain, food plants, fertility, and fecundity of humans, animals, and all nature. But they also had an unintended function in the history of Huichol art: they helped prepare the way for its extraordinary flowering in the second half of the 20th century.

For a people as dependent on rain as are the agricultural Huichols, there is really nothing more magical than the coming of the rains after a long period of drought, when the whole landscape is suddenly transformed. Among the many female deities there is even one that expresses this thirst for the life-giving rain: Our Mother 'Utuanáka, the Earth Moistened by Rain and Ready for Planting.

In an old creation story circulating in the Sierra, the rain goddesses were the first beings the old creator goddess brought up from the depths of the primordial sea, the world ocean in which all life originated. At that time the only other living being was the Morning Star. To allow the rain goddesses to climb up out of the sea and rise into the heavens in the form of clouds, the old goddess hung her long white hair into the water.

But once they had reached their place in the sky the rain goddesses felt useless, because there was as yet no earth for them to moisten. So the old goddess sent them back down to bring up some of the mud that covered the ocean bottom. She took the mud, fashioned it into a ball, and laid it in the center of a cross of two sticks tied

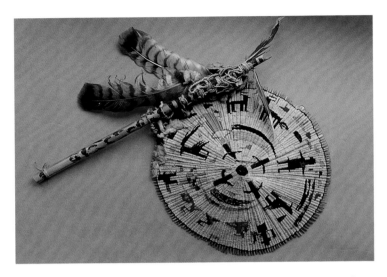

Fig. 33. Prayer arrow and splint nieríka for rain and Great-grandfather Deer Tail, presented to Konrad Theodor Preuss in 1906 at Santa Gertrudis in the Huichol Sierra. Dia. 11-3/8 in. Preuss Archive, Museum für Völkerkunde, Berlin-Dahlem.

together with her hair which the Morning Star had made at her direction. This was the first thread cross, *tsikúri* in Huichol, a four-directional protective prayer object that was unfortunately misnamed "eye of god" by Lumholtz (for old examples and their use, see Fig. 29). She pressed down on the mud ball to flatten it until it was large enough to sustain the life awaiting birth from the sea.

A century after Lumholtz the votive gourd bowls have not lost their power to communicate with the deities, and in the mind's eye fill themselves with the fruits of the fields. Indeed, they remain so efficacious a means of influencing the higher powers that they have their own temple custodians, called Guardians of the Votive Bowls.

From Votive Gourd Bowl to Nieríka

In the mid-1950s something happened in Huichol art that not only changed its character, at least pushing it in new directions, but would eventually propel it onto the world stage. What happened was this: A museum specialist named Alfonso Soto Soria came to Guadalajara from Mexico City to organize a folk art exhibition and to purchase Indian arts and crafts for the National Museum of Anthropology. Guadalajara is the capital of the west Mexican state of Jalisco (which includes much of the Huichol country in the Sierra Madre Occidental). It had long been—as it still is today—a magnet for Huichols forced by lack of arable land and other factors to seek urban employment and augment their meager income from the sale of arts and crafts to tourists and the gener-

al public. Their modest wares then as now included above all finger-woven beaded bracelets, rings and ear ornaments, "eyes of god," and their womenfolk's beautiful weavings and embroideries.

The National Museum of Anthropology, then still inadequately housed in a 300-year-old Spanish colonial palace in the center of the capital, already had a small collection of Huichol arts, including some fine old votive gourds. These and some other votive objects with imagery of yarn and wax gave Soto Soria an inspired idea: what if he could persuade some Huichol artisans to use the same technique of embellishing the interiors of votive gourds with yarn, glass beads, and wax designs to decorate flat

Fig. 34. Detail of a woman's cotton skirt with cross-stitch embroidery by Guadalupe de la Cruz Ríos. Private collection.

wooden boards suitable for hanging on a wall? It would provide him with some new and unusual objects for the exhibition and at the same time give the Huichols an added source of income.

Soto Soria broached the idea to four Huichol men he met selling crafts, and in conversation discovered that all four were shamans. They were poor, unhappy in the city, missing the peace and beauty of the Sierra (as Huichol transplants or temporary visitors to the city still do today), and ready to experiment. The idea sounded fine, but they were utterly without means to purchase the wool yarn, beeswax, and wooden boards. Soto Soria would provide the raw materials if they would agree to "paint" with yarn. And so was born a new uniquely Huichol art, the yarn painting.

Actually what was new was only the shift from a rounded to a flat surface, and even that was not completely new. Huichols had on occasion been using not only mineral and vegetable paint but wool yarn for symbolic designs pasted on stone or wood or ingeniously woven into splints (Fig. 33). More fundamental was the conversion of what had always been a sacramental offering into décor—without, however, diluting or expunging the original purpose.

To borrow motifs from the rich inventory of sacred or votive arts and turn them into pure decoration was not in and of itself all that new: the same thing was regularly done in the cross-stitch embroidery with which Huichol women decorated their and their men's clothing (Fig. 34). Cross-stitch embroidery was relatively new, having been taught by the nuns to Indian children enrolled in Catholic boarding schools. Weaving on the backstrap loom was much older, dating to Precolumbian times, and among the Huichols was fraught with complex symbolism that reached deep into mythology, shamanism, and the sacred.

In any event, motifs of deer, rabbit, turkey, peyote, pine, opossum, squirrel, bee, scorpion, maize, beaded lizard (a poisonous relative of the so-called Gila Monster of the southwestern U.S.) (Fig. 35), and other life forms familiar from the sacred arts started to appear, alone or in symmetrical juxtaposition, in yarn paintings.

Initially the yarn paintings were rarely larger than a foot square. But as the thick and heavy boards gave way to thinner and lighter plywood and, eventually, Masonite, yarn paintings expanded to 2 feet by 2 feet and even larger sizes. By the early 1960s, there were even a few decorative yarn paintings with purely Huichol motifs as large as 4 feet by 8 feet.

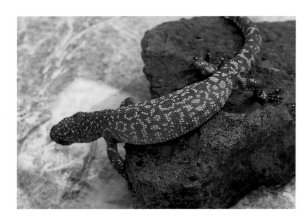

Fig. 35. The poisonous Beaded Lizard (*Heloderma horridum*), a Mexican relative of the equally sluggish Gila Monster (*Heloderma suspectum*) of Arizona, is held in great respect by Huichols who seemingly show no fear of its powerful jaws. San Andrés Cohamiata, Sierra Madre Occidental. 1967.

In the meantime, Padre Ernesto Loera Ochóa, a Franciscan priest with sympathy for the Huichols and respect for their traditional culture, had established a store and museum for Huichol arts and crafts at his church, the Basílica de Zapópan, home to Guadalajara's patron, the Virgin of Zapópan, located just outside the city.

The store bought their work and resold it to the public. Padre Ernesto also commissioned yarn paintings for his church. This and growing interest, academic as well as popular, in Huichol art and culture had, by the 1960s, provided these part-time urban artisans with a more or less steady outlet for their work.

Bee Boy's Magical Gift

One thing on which the artists were agreed: the yarn might be commercial, but the wax into which it was pressed had to come from the indigenous stingless bee. Precolumbian Mexico had only a few domesticated animals. The stingless bee, smaller than the European honeybee and less productive, was one of these, along with the dog, the turkey, and probably the duck.

Mixed with powdered tree resin as a hardener, the indigenous wax was more malleable and more easily spread into a thin adhesive base than wax from the European honeybee. But that was not the sole reason for its use. Rather, it, too, had to do with sacred myth. Like turkeys and other native species, indigenous bees were once people, the Bee People of origin mythology. Wax came into the world for use in the sacred arts when the body of one of their number, named Bee Boy, was cremated, and liquid wax flowed from his body in place of blood.

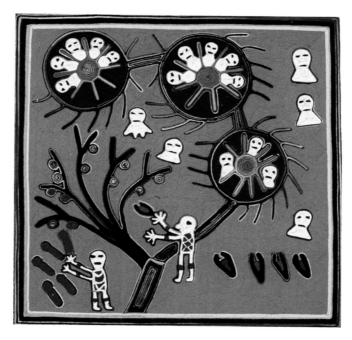

Fig. 36. Ramón Medina's nieríka of the soul's arrival in the village of the deceased. His explanation: To get to the beyond, the male and female souls (lower left) are expected to carry the physical evidence of their sexual lives, the male bringing vaginas, the female, male organs. These they must fling into a tree of life to knock down fruit for a fermented drink to feed the dead and help them celebrate their arrival. Moral: no active sex life, no feeding of the ancestors, and thus no continuity of life. 24 in. by 24 in. Fowler Museum of Cultural History.

Their insistence on indigenous wax is not to say that Huichols have no use for the imported kind. On the contrary, like the axe, the machete, the violin and the guitar, and a host of other useful manufactured goods, Huichols readily adopted the candle to light up their windowless one-room dwellings. Even more important, it was a portable form of Grandfather Fire that guarded people engaged in sacred activities that exposed them to the machinations of witches and sorcerers.

During the 1960s the number of accomplished "painters in yarn" grew substantially. But their work remained decorative—what one of the best and most innovative of their number, the above-mentioned Ramón Medina, called *puros adorno*, 'pure décor.'

But one day in the summer of 1965, with a little prodding from this writer and Padre Ernesto, yarn painting took a radical new turn, from puro adorno to pictorial narrative. Why not use his art, we asked Ramón, to illustrate his stories and his visions? Puzzled at first, Ramón, who was then well into self-training as a shaman, pro-

duced a yarn painting two days later (Fig. 36) that went with a story of the journey of the soul after death he had been dictating in fits and starts over the better part of the week.

With a brilliant orange background it had obvious sexual overtones, but it also afforded a rare insight into Huichol conceptions of reciprocity between the living and the dead, fertility, and continuity between the generations. Though the first of this brand-new tradition of story-telling yarn art, it was actually the last of a four-part series of visualizations of a soul's progress from this world to the other.

On this journey culture hero and shaman serve as psychopomps, or soul guides, the latter telling, as Ramón had been doing, of the dead person's adventures at a ceremony of the final farewell held by the survivors. As recited by Ramón, when a soul embarks on this final journey, it is burdened with the evidence of all the love-making he or she had done in "that other life." As it also does in a surprisingly similar Hopi tradition recorded years ago on Second Mesa but not published until long after Ramón's recitation, the female soul carries a basket filled with male organs, the male soul a basket with female organs. Depending on how active she or he had been, the load can be considerable. But there is compensation: when it arrives in the underworld village of its ancestors, it is told to fling the evidence of its worldly activity into a tree of life laden with fruit. The waiting relatives need the fruit to ferment an intoxicating drink with which to celebrate its

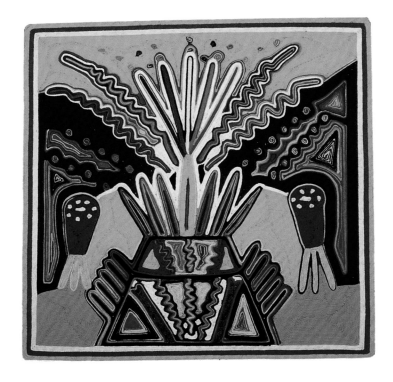

Fig. 37. A wool yarn nieríka by Ramón Medina of Grandfather Fire. His explanation: In his peyote dream in Wirikúta, he saw the old fire god and patron deity of shamans with two "guardian peyotes" not as a person but as a burst of multicolored flames from the ceremonial fire, not only above ground but with his "roots," and those of the peyote, under the earth. 24 in. by 24 in. Fowler Museum of Cultural History.

arrival. If the soul came with empty hands, there would be no celebration, no festive drinking, and no continuity of life. It was this high point in the story that Ramón illustrated in his very first attempt at what eventually would become a great new indigenous art tradition.

Ramón's new narrative yarn paintings met with immediate success. From then until his untimely death in the summer of 1971, every yarn painting he created—and there were many dozens—was an illustration of a myth or a vision.

Much of his art went to the ethnic arts collection of the University of California at Los Angeles (now the Fowler Museum of Cultural History). In 1968, the Los Angeles County Museum of Natural History gave him a one-man exhibition, the first time that Huichol yarn paintings had been exhibited in the United States.

He worked in a stick-figure style reminiscent of the Precolumbian pictorial codices (Fig. 36). His followers, including Benítez, continued for a time in the same tradition. Some do so to this day, because they prefer it and also because it keeps his memory alive. Others soon veered off in new, not to say revolutionary, directions. Of these, by far the most daring was Benítez.

With his first foray into narrative art Ramón began to use the term *nieríka* for his yarn paintings. For Huichols *nieríka* (pl. nierakate) has many meanings, all directly or indirectly connected with the spiritual and the realm of deities and ancestors. It is applied to many kinds of ceremonial or sacred art, both abstract and representational. It can be understood as mirror, likeness, face, aspect, or image of Otherworlds, and conversely as doorway or portal into "non-ordinary reality," the realm of the divine, creation, and transformation. Her Huichol friends explained to the anthropologist Stacy B. Schaefer, a student of Huichol intellectual culture and women's arts, that the term can also mean a person's predestined skill, sagacity, knowledge, and understanding. As Lumholtz discovered more than a century ago, almost any object that symbolizes the "supernatural" can be a sacred nieríka: ancient rock art; the round, polygonal, or rectangular shields of interwoven splints and yarn; woven disks or "shields" depicting, as recognizably as the technique will allow, a deity and his or her associated animals and plants; a miniature stone seat of one of the deities; a deer trap; decorated votive gourd bowls; store-bought mirrors, by themselves or incorporated into sacred art; a shaman's basket; a prayer arrow; and even the divine peyote cactus.

To qualify as a nieríka, the object need not even be decorated. It can be a piece of yarn or string with something attached to it. As an example, in his 1900 monograph on sacred art and artifacts, Lumholtz illustrated an undecorated gourd-like object that hung, blackened by smoke, under the roof of the tuki in the comunidad indígena of Santa Catarina. It had no design whatsoever. But it turned out to be not just a nieríka, but the nieríka of the very heart of Grandfather Fire, and hence sacrosanct and powerful beyond words.

Almost from the moment the yarn painting ceased to be merely décor and, in mid-1965, began to mirror sacred myths and the artist's visions, it, too, joined the exalted company of nieríkate.

Two Huichol Origin Myths

Even a shaman's visions do not appear in a literary vacuum. Like Benítez's visual interpretations of "non-ordinary reality," they found their inspiration in Huichol oral poetry, the great stories of the First Times of creation and transformation that shamans learn by heart and that Benítez first heard from his shaman father.

His cousin Ramón Medina had pointed the way, as story-teller as much as the pioneering artist of the narrative yarn painting. Many Huichol shamans are gifted raconteurs; in fact, it is precisely their talents as singers of the sacred chants, their ability to make the ancient unwritten texts come alive, that confirm and enhance the social and spiritual power, and the prestige, of shamans in whatever society they function.

The following origin myths represent but a fraction of the treasury of Huichol oral poetry, whose recitation would consume a month and more of nightly performance and even then would not be nearly complete. These and many other stories were dictated in 1966 and 1967 by Ramón, whose Huichol name was 'Uru Temay (Young Arrow Person or Newly Made Arrow). Like the myths of indigenous peoples throughout the world, they are by no means the only versions of the events they describe. But as their very own literary inheritance that has survived centuries of pressure for change, the ancient stories help give all Huichols, not just specialists in the sacred and inspired artist-shamans like José Benítez Sánchez, a sense of their own and their culture's uniqueness.

How the Sun Father Came into the World

It was dark in those days. Darkness was on this earth.

In the day it was dark. In the night it was dark. There was no Tayaupá [Our Father, the Sun, also called Tawerikúa, 'Our Eagle'] to light up the day.

There were persons in those days who were not of this world. There was Takútsi [Our Great-grandmother] Nakawé, the old one, the ancient one. The one who started the world. The one who set up the trees, the sacred trees of brazil wood, who set the four trees in their places. To the south, to the north, to the east, and down below [west]. And the fifth one in the center. The trees that hold up this world.

In those ancient times there was a lake, very large, shining, blue and green, where Our Mother Haramara dwells, where the sea [the Pacific Ocean] is. Blue, blue, this sea. And Takutsi Nakawé began to ask, she asked those others who were there, "How are we going to do this thing? How shall the sun light our path so that we shall see, in this way or that?"

This is how the birth of Our Father, of the Sun, came to be. It came to be this way.

There were many small boys, young, four, five, six years old. They were playing there, pretty those boys, beautiful. It was said of them, "One must

go into this lake, we must throw him in there, so that he shall be born over there. So that he shall light our way."

Then they grabbed him, they took this poor boy, they got hold of him. They threw him into the water so that he would be born on a breeze from the sea, brilliantly, in brilliant colors. So that he would light up our paths.

But imagine—it refused him. That water, it rejected him. It rejected him because he was not pure, he was too full of transgressions. Imagine how it should be. One must take care of oneself. In the same manner that one becomes a mara'akáme.

Well. Then they brought another little boy. Beautiful, beautiful, that boy. Well adorned. They did the same to him. And for a time it seemed as if this little boy might do it. That he might be able to accomplish it. They waited. But no, it was not possible. It rejected him. And he left and they brought another boy, another little boy who was there, playing. Well adorned, like the first one, like the second one. In the same manner it was not possible.

And they brought another boy, one who was four, five, six years old. Very well, it was not possible.

Ah, there was another one, five, six years old. Well dressed, well painted. With his little bags on one side and the other, with his little cape, his little hat, with his wristbands and his rings, with his sandals, with his bow and arrows. All authentic, all Huichol. How was he? He was like a little Huichol, a Huicholito, as one says. So fine, so beautiful. He was an orphan, that one, a poor boy. He had his sandals, yet he was barefoot. He had only a mother. He had no father, nothing.

There he was, playing in a little barranca there, along a little slope. He played with a circle made from a nopal cactus. An old nopal, very old. There he played, all alone, with his bow, his arrows, rolling that nopal, shooting it with his arrows [a version of the pan-Native American hoop and stick game]. Contented.

She [his mother] saw how it was. She said, "Ah, if that is how it is. It has to be that way."

She said, "Yes, I am in accord. I give my word. My permission."

She knew, she was Our Mother Niwétsika [the maize goddess]. She said, "I am in accord but you must ask him, you must speak to my son, you must ask his agreement."

They told her, "Yes, we will speak to him."

So they spoke to him. He said to them, "Yes, I am in accord with you. I am in accord that I shall become Our Father, the Sun."

But being as he was, this pleasing child said to them, "You must be thinking that I am one of importance. But no, I am only a poor boy, an

orphan. I have sandals, yet I walk barefoot. I have no father. I have only my mother." And he said, "It will be hard on her, on my mother, who is going to be left all alone in this world. No one to support her, no one to give her food."

They said to him, "Do not worry, do not break your heart. We will see how we will support her."

So he said to them, "Yes, I agree, but I will make a bargain with you. I will take my sandals, I will take my wristbands, I will take my bow and arrows, I will take my little bags, everything, to all sides. I am painted, my face is shining, it is painted with the yellow paint of the peyote country [made from the roots of a plant native to the Chihuahuan desert, *Mahonia trifoliolata* var. *glauca*].

"But do not leave my mother here. If you bring her with you, it will be well, it will be as you wish it. As I go over there [east], defending myself with my bow, with my arrows, I shall speak to you, five times, to see how it is."

They said, "It shall be as you say."

Then they take him, this beautiful child, this poor boy. He cries, he is crying, he does not want to leave his mother. He is crying, perhaps he might die as he is thrown into the water, into the blue lake. And his mother cries out as she sees him in this way.

The fiercest animals are in that water [the watery underworld] to devour him as he goes along. She cries, "Ah, my son, my little son! My son, he is going to leave me, forever he will leave me. Perhaps he is going to die, he is going to be devoured as he goes."

They say to her, "Do not worry, do not break your heart. We will see how we will manage. We are taking you with us as he said."

They come to the water, carrying him there. They throw him, that poor little boy, shining in his clothes, shining in his face paint. They throw him. And the water rises, as if boiling, it rises, it foams, it rises up, up. He is in there. And to the surface of that lake, so blue, so blue, there comes blood, blood, blood. Red, very red, crimson, very beautiful, oh so beautiful, so brilliant. They took it for anointing. Red, red, sacred was that blood that came over there to the surface of the sea.

And that boy, he said to them, there in the water, "Ah, as I told you, I shall go there walking [to the east]."

Down he went. One level, two levels, three, four, the fifth level. Until he reached the bottom of that lake. And then he began to make a noise, like a deep, deep breath, saying, "Wiwiwiwiwiwiwiwi."

Arriving at last at a plain, a level plain, he said, "Ah, now I shall walk, over there."

He came to the first level. He spoke to them. Over there the

Mara'akáme [Tatewarí, Our Grandfather Fire] was listening to everything. Listening as he walked, listening as he spoke.

He walked to the second level. Again he called to them. He said, "What happened? What have I asked of you? My mother, you have her at your side?" The Mara'akáme answered him, "Yes, do not worry. Your mother is walking here. Do not worry."

There he went, walking. He came to the third level. Again the same thing. His mother was there, she was over there.

At the fifth level he said, "Ah, it is here that we have the reality. Here is all, here is the shaman, here we will embrace. We are companions, the Mara'akáme and I. This way we will manage our lives."

At this time the animal people were betting in which color he would emerge, in which form he would emerge. They did not know what his color would be. How he would look. What his face painting would be.

When a ray emerged, one would say, "Ah, here he comes, yellow." Then another ray would break through and that one would say, "Ah, here comes a blue one, he will come out blue." Thus all were betting there. They wanted to name it, there where he was coming through. On that mountain we call the Mountain that Burned [an inactive volcano called Cerro Quemado in Spanish, Reu'unaxi in Huichol], which is near Wirikúta, where it is called San Luis Potosí, where we go for the peyote.

He was born over there. Such a beautiful birth, beautiful. Like Tatewarí, like the Fire which we adore. All of them were over there, betting, asking, "What will it be like? How will it look? What form will it have? What will we name it?"

So they spoke, all of them who were there when he was born. Tatéi 'Ipáu, the snake with two heads, Wexu [a variety of the boa constrictor women weavers recruit as a spirit ally and model for their weaving designs], Xainu, another snake, 'Imúkwi [beaded lizard, a sacred animal related to the Gila monster of the arid Southwest; see Fig. 35], 'Atakwia, Kurúi, Kurúpu, all of them sacred animals of the Sun, from the time the Sun was born. And Tasiu [Rabbit], Tüwe [Jaguar], all of them very sacred. Those were the ones that held the contest. There they were with the Mara'akáme. He arranged it all.

Well, then another ray appeared. The Sun was ready to be born. The ray calmed them, those who were there, and they began to look for him. They began to look under the stones, and some under the earth, and some under the bark of the tree, and some among the trees, and some here and there, to see where it would appear, how it would look. The Mara'akáme ordered them to make the offerings, the sacred things, the [votive gourd] bowls, the altar, all those things, all those things that belong to the Sun. So that all should be in its place.

When the Sun came up. When Our Father emerged there, from the Mountain that Burned, he said, "Ah, what is my name?"

The Mara'akáme said, "Who will be the one to name him?"

Ah, it was a female turkey who did it. Turkey said, "Xupí, táu, táu, táu, táu, táutáutáutáutáu." And he said, "Ah, that is Our Father, the Sun. Táu. So he is called." That is what the female turkey said.

And then all of them exclaimed, "Oh, that is what I was going to say, that is what I was going to call him." It was Turkey who named him. That is why the turkey is sacred, sacred to the sun, the proper offering.

Ah, in those days it was as if to melt the earth, when he was born. When the Sun, when Our Father was born, he was strong, he was shining, hot. When he was born, the stones began to come up, flying up, a great roaring came there on the Mountain that Burned. He was born and that mountain exploded.

He was worn out, tired, from that journey. He had walked, using his bow, his arrows, defending himself as he went. The Mara'akáme told them to make a chair for him, so that he could rise to the sky. That is how he rose, in the chair. They embraced there, the shaman, and Our Father. So that it should be that way from then on. The Mara'akáme and the Sun, companions all their lives.

That is how it began in those days.

How the Animal People Stole Fire

This is another story that comes down to us from Ancient Times, from the time when Our Grandfather [Fire] was being born over there, where Our Mother Haramara [the Pacific Ocean] dwells. Where they were guarding him.

Some who lived then thought themselves to be people, persons of knowledge, even some who thought they were more than the Mara'akáme [Grandfather Fire, the First Shaman]. One who believed himself to be a person was Water Snake. Another was Boa Snake. Another was Colored Snake. Another, Centipede. Another, Turtle. Some said one thing, others said another. They were animals, pure animals, yet they thought themselves to be people.

When Our Father [the Sun God] was born, it was light. During the day it was light. One could see. One could see in this direction, in that, in the direction of the four winds. But it was not complete.

"Ah," some of them said, "Look, at night we must live in darkness." They said, "Ah, we have nothing to cook with, nothing with which to keep ourselves warm. In what manner are we going to eat our food?"

They were eating everything, everything raw. They said, "Look how dark it is. Look how cold it is. We must obtain Our Grandfather [Fire], because we are still lacking him. What are we going to do when we are cold? What are we going to do when we are hungry? One cannot eat raw things in this world. What are we going to cook with? With what will we make our tortillas?"

And they asked, "From where are we going to obtain it?"

Another said, "You know very well that it is down there, to the west, where the sea is, where our Mother Haramara is, that they are guarding him." And another said, "If that is how it is, how will we manage this? How will we bring him here?"

Then one who believed himself to be more than the others said, "You are going to go down there for him, because they do not want to give him up. They don't want to sell him, or give him away, nothing."

And he said to them, "You are going to go to that mountain as if you were going to dig up *camotes* [sweet potatoes] for our nourishment. As if you were going to clear land. As if you were going for beehives. There are beehives there where you are going, fat beehives, chestnut-colored, walnut-colored. That is the one Our Father [the Sun] prefers for candles, for everything."

"Very well," one said, "I will go." This one had his bags. The little bags one carries along, the little hat, like those the Huichols wear today. He went along, walking, walking. There he went through the mountains, digging,

rolling stones. Those over there were watching Fire, watching Our Grandfather. Listening. The stones were rolling, rolling. It turned dark. Over there, that one sees a pretty light, shining. A very pretty light. He says to himself, "Ah, I wonder what it is. I wonder how one feels there. I am cold. I wonder if it is warm there."

So he spoke, saying, "I would like to come close. To see if I can warm myself a little with that. I wonder if it is wise to go there? What if they chase me away from there? What if they kill me?" He didn't know what to think. He had many thoughts in his heart. Many, many things to think about. Many things to think of in order to bring that thing back.

He went walking, walking, until he arrived there, at the place where that light was shining, where Our Grandfather was. Having arrived there, he told them, "Good afternoon." They replied, "Good afternoon. What are you doing here?"

He said, "Oh, around here I came to dig up some sweet potatoes for our nourishment. I came to find beehives. To see who could aid me around here, because it is very dark, and one cannot see well. We do not know what to do."

They said, "Oh, but what can we do?" He said, "Won't you give me a little spot where I can sleep, even if it is only for tonight? I am very cold. And I saw that light. I saw this light and I asked myself, 'I wonder what it is. It is a very pretty light it gives out. I wonder if I can find out what it is.' So I thought and I came. Here I am with you all."

They said to him, "Aren't you going to steal Our Grandfather from us?"

"No, no, that is not in my thoughts. I bring good thoughts, a good heart for everything. Don't think about that." They said, "Very well, come in."

It is very cold. Then he draws near Tatewarí [Our Grandfather, Fire]. He says, "Ah, how very pretty. I was cold. Oh, how warm, oh, how nice it feels here, very soft, very beautiful. Oh Tatewarí!" And all that time he is thinking, thinking in his heart,

"Ah, I wish I could go to sleep. I hope I can take even a small piece back to my rancho, from where I was sent, so we can also have this over there. Because over there we have nothing with which to eat, we are without a thing, without food, without anything to cook, nothing of that sort. Oh, My Mothers, My Fathers! How are we going to manage it?"

Well, this way. He went there to lie down next to Tatewarí, very close. Then he acted as though he were asleep. About one or two o'clock in the morning he woke up. They went back to sleep, those who were guarding Tatewarí, they also woke up. They went back to sleep. He woke up again.

"Ah," he said, "now they are really asleep, they are snoring, they are fast asleep."

Then he took a piece of wood and put it in Tatewarí. The wood caught fire, such a pretty fire, to the four winds, the four directions of the wind. He picked it up, "Ah, such a pretty fire." He said, "I am going to take it to my ranchería so that we also can have a good fire, so that we can be as they are. Happy, enchanted with life. Very well."

Then he acclaimed it to the four winds, this way and that, to the four winds. Then he started walking. He said, "Yes, I have to steal it, there is no other way, surely I have to steal it, to take it with me."

So he set out walking, walking. There were five [levels] there, five. When he reached the first level, there they caught up with him. They awakened and saw how he was leaving with the lighted wood. And there they were. They chopped him up into little pieces, they began with his little head, then his little hands, and his little feet, his little stomach, bit by bit, all of him. That is the way they left him, the poor man. Because he had stolen that, because they would not let him take it.

Well, they left him there, all chopped up into little pieces. And this poor person, this poor man, he got up as well as he could and said, "Oh My Mothers, My Fathers! Tatewarí, how can we manage to take him? Ah, they take much care of it. Surely over there, he who sent me, what am I going to tell him?"

So he went, saying, "Ah, he cannot accuse me. I am not lying. I am not surrounding myself with lies. They are guarding it too well."

He left, and when he arrived [up] there, he said, "Look, I brought nothing. They caught up with me, those who are watching it, and they took it away from me. They took it back."

And that other one said, "No, you must be lying. You did not go, you did not go. They do not watch it that much." He said, "No, no, it is well watched. Because they are taking care of it well."

Very well. He said, "Let there be another who will go for it."

Another one goes. He did the same thing that the first one did. He arrived there in the afternoon. He said, "Good afternoon." They replied, "Good afternoon. Come in."

He told them, "Could you give me just a little place for the night, if you happen to have any such thing? Just a little corner where I can sleep? I saw that light, that very pretty light, and I asked myself, 'Ah, I wonder what one feels like over there, close to it.' So I came."

They said to him, "You are one of those who come to steal Tatewarí." He said, "No, no, not I. If another person did that, it was not I. I am a humble man. Did you not hear those stones rolling, did you not hear the sounds of my machete? Cutting the trees? That is what I was doing."

They said "If that is how it is," and they told him to stay.

Then it got dark. They brought the brazil wood, the oak wood, the

evergreen wood, the pine kindling, to light it.

"Ah, good." He saw how this was the food Tatewarí made for himself, that this was the food of Our Grandfather. It was the firewood. As one eats tortillas, as one eats an ear of maize. One feels satisfied. In this same manner, Tatewarí. With that wood he has enough. He feels contented, full, enchanted with life.

Well, they went to sleep. Around midnight, he arose. He said, "Now, ah, my heart, we will take Tatewarí." Yes. Then he took a piece of wood, the most sacred wood, which is brazil. That is the sacred firewood of Tatewarí. For everything it is the most sacred wood. So he took the brazil wood. He directed it to the four winds.

"Ah," he said, "I am going to steal Tatewarí. We have to take him with us, no matter what."

Well, he took it, he started walking. He walked and walked and when he had reached the second level, they caught up with him. And they did the same to him as they had done to that other one. They chopped him into little pieces.

When he arrived [up] there, he said, "The same thing that happened to the other one happened to me. I did not believe it when he said that, but it is true. It was the same thing."

So they sent another one. That other one went and the same thing happened. He went digging out sweet potatoes. He went chopping down trees. He went rolling stones. Darkness was close and he saw that one also, that pretty light.

He arrived there, saying, "Ah, good afternoon." They said, "Good afternoon." And they said, "Aren't you the one who has come to steal Tatewarí?"

"Oh no, not I."

"How do you say no? You are the one."

"Oh no. I have only come for a little space to spend the night. So I can sleep. Tomorrow I will set out on my way."

They said, "All right then, come in."

So he went in there. He said, "Oh, how pretty Tatewarí is. He warms me well. I am very warm, I am hot. I was cold, cold out there. But what can one do?" Well, he would get up, he would go lie down, he would get up, he would lie down. He was somewhat more clever than those others. He would look around him and see there were five guarding Tatewarí. Then around midnight he got up and went around touching their hearts. Ah, this one is asleep. Now this other one, he is asleep too. This other one, he also is asleep.

He did as the other one had done, following the same path. The same sacred wood, which is brazil. It is the wood one uses to make offerings, to

make the [prayer] arrows. Tatewarí has blessed it.

Well, he did the same to the four winds. Then he left with it, burning. When he reached the third level they caught up with him. They did the same with him as with those others. They chopped him up into little pieces. He could not take Tatewarí with him.

After they had chopped him up he got up and exclaimed, "Oh, what will we do now? If that is how it is, what am I going to say there when I arrive? Well, I am going to tell them this way and the other." He left there and arrived.

They said, "What happened there? What did you bring?" He told them, "They chopped me up into little pieces, some with machetes, some stoning me, some with clubs, some kicked me. And I did not bring anything."

Well, another leaves. That makes four. He said, "Let's see if I can." He came to the mountain and did the same as the others. In the late afternoon he arrived and said, "Good afternoon." They said, "Ah. There is another one coming to steal Tatewarí. He said, "Oh no, that is not how I am. I am not like that. I am pure, all of me. You may search me to see if I have anything to steal him with."

And they went to sleep. Around midnight he got up. They were snoring, fast asleep. In the same way he took it, the sacred wood. He took it to the four winds. He made a fire, a very pretty fire. Then he took to the road, saying, "I am going now."

That one, he reached the fourth level. They caught up with him. They did the same thing with him.

He said, "Oh, now what are we going to do? If we don't take it, we are lost. All the animals are going to eat us up. They are going to leave us out in the cold. We will have nothing left. We will not be able to attain anything. The Tree of Our Life, what will it give us?" So he spoke, going.

When he had arrived he said, "The same thing happened to me as happened to those others."

Now comes that last one, the fifth one. He said, "How can I go being as I am? I am only a boy. I cannot bring back those things that are sacred." He believed himself to be a person, but that one was Opossum. He is a very sacred animal.

The other one said to him, "Well, then, how are we going to do it? If we have to bring back Tatewarí?" So then he said, Opossum Person said, "Very well then, if that is how it is. I will see how I can do it."

That animal is very sacred. It seems to be an animal that is worth nothing, but it is very sacred. An animal of a thousand graces. He went. He took the road of Opossum. He started out there in the manner that he is used to, digging all the time, in the trees, in the stones. He started there. Knocking down stones, knocking down trees, chopping down what was in

his path. He went doing and undoing, that one. So that they would think he was no one.

Well, after so much walking over there, he saw where Our Mother Haramara was. Then he saw Tatewarí. The fire, the flames, very pretty. He said, "Oh, how beautiful, how very beautiful. That light over there. How can I do this? I am going to arrive there and tell them I want to spend the night there. I will ask permission to spend the night there. Just one night. That should be enough."

He took his bow and his arrows. He took his machete. He gave four offerings to his bow and arrows, to the four winds. He prayed toward the four winds. He said, "With this I defend myself, with this also."

Very well, now he could see everything clearly. Everything looked complete, on one side and on the other. He saw his sandals, he saw the soft spot on his head [the anterior fontanel, seat of the soul]. He examined his mind, his brain, to see how he would do this thing. His heart, all of his heart he saw, he searched his heart. Very well he searched it. He said, "This is how I am." He said, "I am all right." Well, then.

He stepped down into the ravine so that he could see where Tatewarí was kept. Then he called out, a pretty call, "Oh, here I am, walking here so that I can visit you." So he called out to them. Then he walked down over there.

Having arrived, he said, "Good afternoon." They said, "Well, good afternoon. No, don't you come here, because you are coming to steal Tatewarí. All of you are coming to steal Tatewarí."

He said, "Ah no, not I. That is not how my heart is. I do not think of such things. If that is how the others are, I am not like that. No, don't you think that of me."

He said to them, "I have come so that you will give me just a place for the night, just a place for the night. So that I can sleep and pass the night very well, in quiet. So that I may go off tomorrow and go on with my work. Except that I saw a light here, a very beautiful light. I said to myself, 'Ah, perhaps I am going to spend the night over there. Where that light is.'"

They said to him, "Very well, then. Come in. Be careful, don't go doing what those others did."

He told them, "Ah, do not worry. I am very weary. Oh, I am so tired! I come very tired from so much walking. Digging out sweet potatoes for my nourishment. Those roots and bulbs that we use."

He thought to himself, "How can this best be done? They are so content here. Eating everything roasted, everything made by the hands of Our Grandfather. How will it be the best way?" So he thought.

One of them saw his thoughts. He said, "No, you are thinking badly. It is better if you go."

He said to him, "No, no, I am not thinking. I am only thinking how tired I am."

They said, "Yes, very well, come in, go to sleep." So that man, that Opossum Person, that boy, arrived so tired, so very tired that he went to sleep.

Those watchers of Tatewarí, they saw him there and they said, "Oh, he has fallen asleep. He is already asleep." They touched his heart, "Oh, he is fast asleep." And they said, "Let us go to sleep." They went to sleep also.

And he, underneath his little hands, watching them, looking. He gets up, saying to the four winds, "To the left I will set a guard, to the right I will set a guard, to this side also, straight ahead to Wirikúta also. Down there [west] in the same way. He said, "Our Mother [Tatéi Werikua] 'Uimári [Our Mother Young Eagle Girl, the all-seeing sky goddess], must help me."

She said, "I will help you."

That Opossum Person, he has his tail very bare. Those others, they were caught because they could not do it. He could do it, with his tail, with his tail that reached in there, into the fire. He took a small piece. And he put it in a little bag [the marsupial pouch] that he carried with him, that he had on him. He put a little piece inside. He said, "Very well, I will take this with me."

He started to walk. He walked with great care, watching. He said, "Ah, they are all asleep." He said, "Let us hope that it will be I who will take Tatewarí out with me. That I will do this thing."

He went. He started walking. He walked to the first level. He walked to the second level. To the third. To the fourth.

"Oh, how good!" He kept on walking. At the fifth level, when he was climbing up, it occurred to him to look back to where they were watching. He blew on Tatewarí—wiwiwiwiwiwiwi! And oh, it lit up, very beautiful. Then he said, he yelled to them, believing himself to be more clever than they, "Look, here I am. Taking Tatewarí. Come and take it away from me!"

Ah, those others saw him. They rushed at him. They climbed up and caught up with him. They chopped him up into a thousand little pieces, one part to one side, another little piece to another side. Little pieces they made of him. They took away what he had in his hand. They took it back with them. They climbed down leaving him there.

There he was, thrown there, dead. They had taken his life away, they had taken everything, dead.

Well, then a while later he reflects. He starts to reflect on this. He starts to get up, to pick up his little pieces. Of skin, of hair, of heart, of everything. Of sandals, of hands, of soft spot on the head, of everything. He put everything back into place.

Once he was back together again he was revived. He felt better. Everything was very well. He became happy. He said, "I wonder if they took that little piece I put inside my bag. That little piece, that bloom of Tatewarí. Didn't they take it?"

He looked. There was that little piece. There was Tatewarí. He took it out and started blowing on it: Wiwiwiwiwiwiwi! Oh, it enlarged, Tatewarí! Ah, Our Grandfather, Our Father!

He said, "Now we will have it. Now our ranchería, our people, our family, will have something to cook with. To become warm. To have to eat, to have nourishment, that with which to sustain ourselves. Everything."

Then he enlarged it again, he enlarged Tatewarí [Fig. 37]. He said to them, to those who were guarding it, those who became gods, "All right, now come and take it away from me!"

He left and arrived there. There, with that chief, that one who thought himself to be more than those others. He said to him, "There, this time I did it."

That other one said, "Ah, my son! How did you manage to get away?"

"This way and that." So he spoke, saying, "They chopped me up into little pieces. In this manner and that they made me into little pieces. I had to put everything together."

Those who stole the fire are animals, animal-people. And those who guarded Tatewarí, they are the ones that became gods, those that went to Wirikúta. Those who were Hewixi [an ancient people, ancestors of the Huichols].

They wouldn't let them have Tatewarí. They did not want to give it away. They only wanted to eat cooked food themselves. So they stole it, those others stole it. That is how it was in those times, as I have told it to you.

Gallery of
José Benítez Sánchez's
NIERÍKAS

The Huichol world is full of things that have more than one identity. For example, deer is peyote, peyote is deer and maize, and maize is also the other two. The basket in which shamans keep their power objects, called *takwátsi*, is a living being, the Deer Person Káuyumari who guides and assists the shaman. In this nieríka, basket and deer unite in the center, surrounded by the shaman's magical paraphernalia and rain serpents.

16 in. by 16 in. 97-15-21

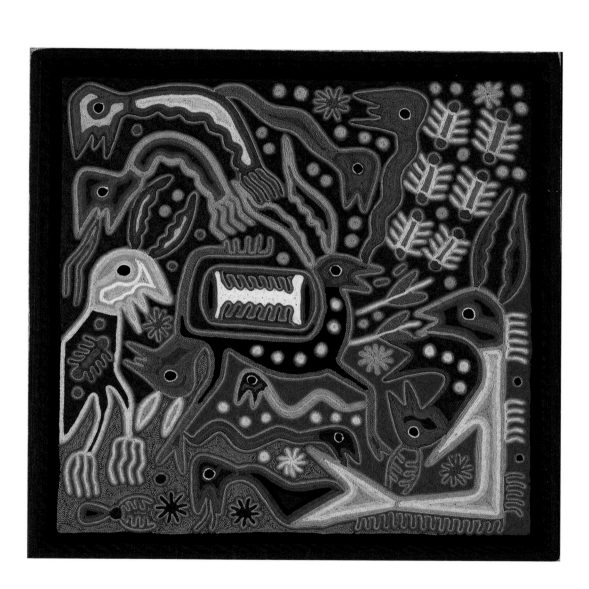

There is conscious life on as well as beneath the earth.
24 in. by 24 in. 97-15-24

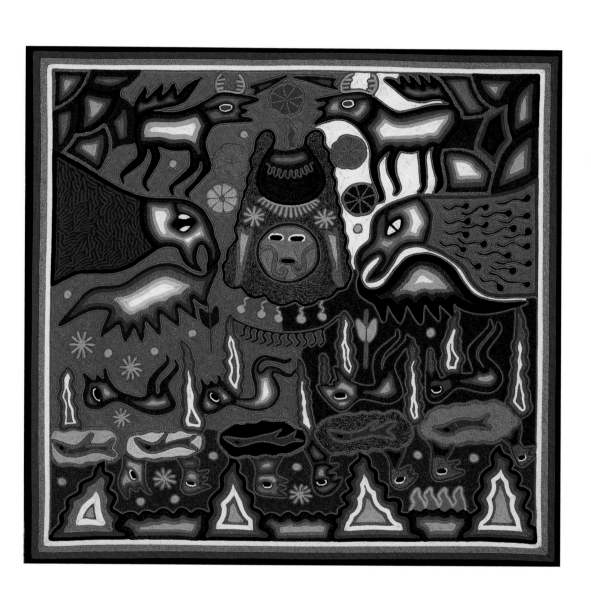

Huichols share with the ancient Aztecs the belief that the last
world before this one was destroyed by water. Only one man sur-
vived, together with a little black female dog. When the dog
removed her skin she turned into a young woman and became
the mother of a new human race. In Benítez's vision the first
birth produced twins, a common motif in Native American
mythologies. Below, a single child emerges from a mother
flanked by a midwife on one side and on the other, upside down,
the antlered culture hero Káuyumari, with hummingbirds sym-
bolizing future children.
24 in. by 32 in. 97-15-4

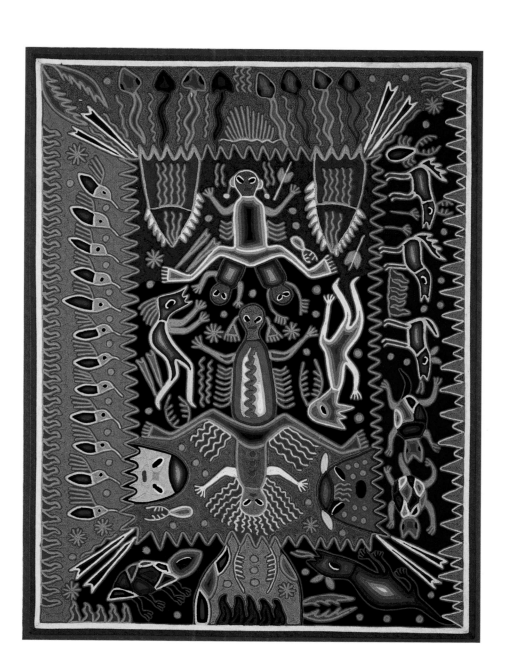

"The first breath of life" is the somewhat cryptic explanation the artist gave for this visionary nieríka of three apparitions of the culture hero and Deer Person Káuyumari in action. At lower right his sacredness is reinforced not only by the antlers on his head but another set on his right knee.

12 in. by 12 in. 97-15-7

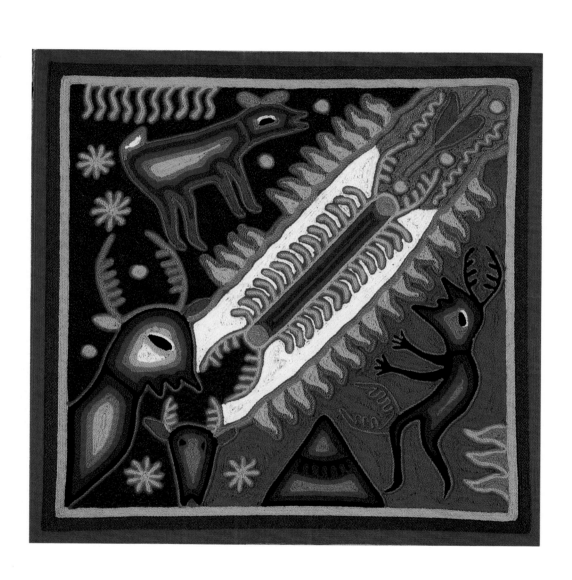

The turbulence of fleeting, ever-changing, and onrushing forms and colors the *peyotero* experiences in ecstatic trance can be misleading. Cultural experience, the great body of oral poetry the shamans perform in ceremonies, and the myths of creation and transformation a Huichol absorbs in childhood have more to do with the content of a vision than does the effect of the peyote on the central nervous system. Behind the seeming chaos of images, there is order and balance, a condition on which Huichols lay great stress.

48 in. by 48 in. 97-15-8

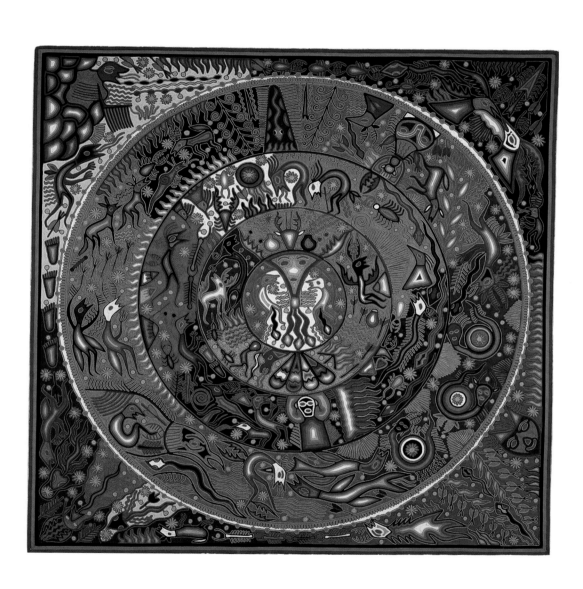

Benítez captures the profusion of iridescent images that flash in endless variety and ever-changing forms and colors across the mind's screen in a peyote vision. Some images in this crowded work stand out: the row of antlered peyotes at upper right, each a different color; innumerable deer, the alter egos of peyote; a pair of facing birds in the center, each containing a tiny human figure. At lower right, a steep-sided mountain in yellow is streaked with white and decorated with deer antlers. On the other side is a white field with a blood-filled artery or vein sprouting flower-like feathered prayer arrows. Below, a reclining deer faces back toward an antlered gourd bowl decorated with a picture of itself. Behind the gourd Káuyumari kneels with hands raised in adoration.

48 in. by 48 in. 97-15-10

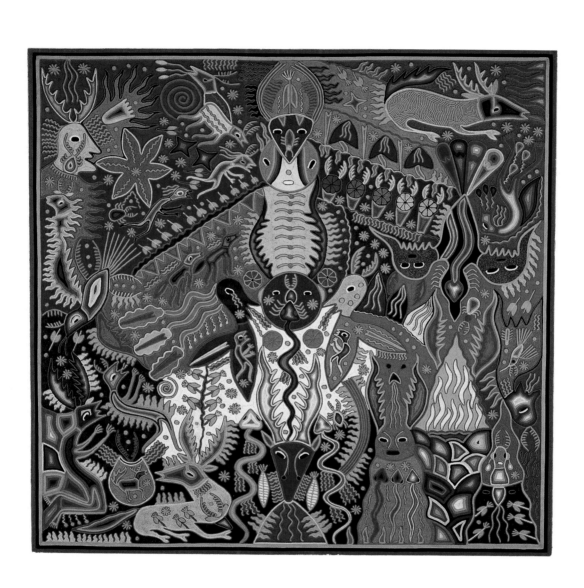

Butterflies mirror perfectly the themes of death and resurrection and of transformation from one state of being to another that are at the core of Huichol religious ideology.
24 in. by 24 in. 97-15-12

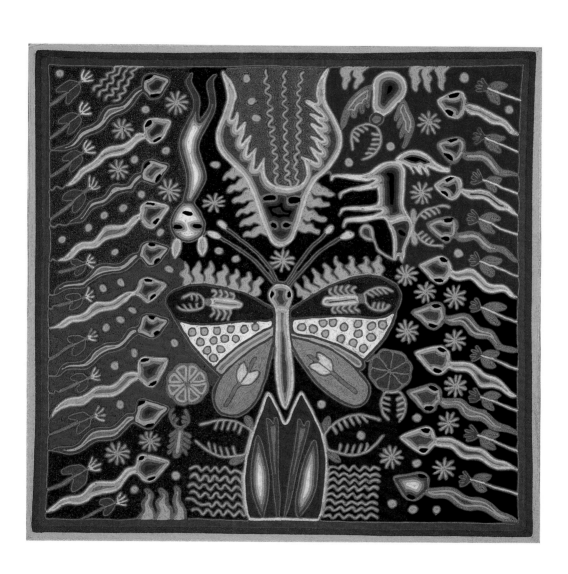

This nieríka takes the shape of a mandala of the sacred circle of peyote, maize, and life-giving celestial waters in the form of rain serpents. At lower right and upper left are the antlers of the sacred deer that is both maize and peyote, and, in the opposite corners, the ants that stole the first maize from the goddess Niwétsika.

16 in. by 16 in. 97-15-15

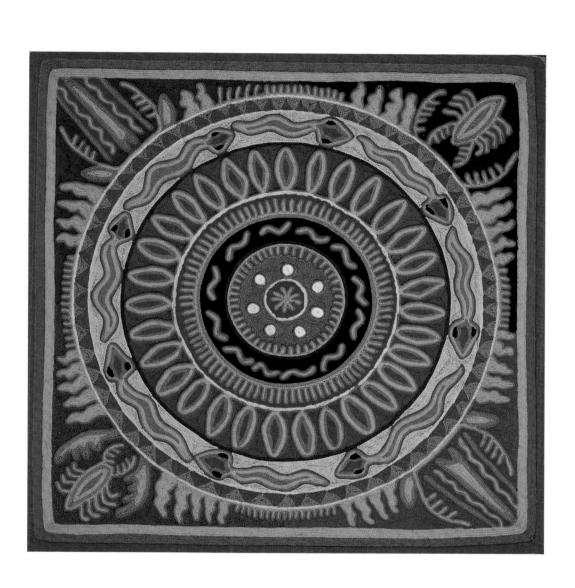

In Benítez's fluid style, a procession of five sacred deer, with majestic antlers and speech or song lines coming from their mouths, passes by in single file. How closely the peyote hunt is tied to Huichol hopes for rain is evident in the undulating rain serpents rising into the sky between each pair of deer horns. 24 in. by 24 in. 97-15-3

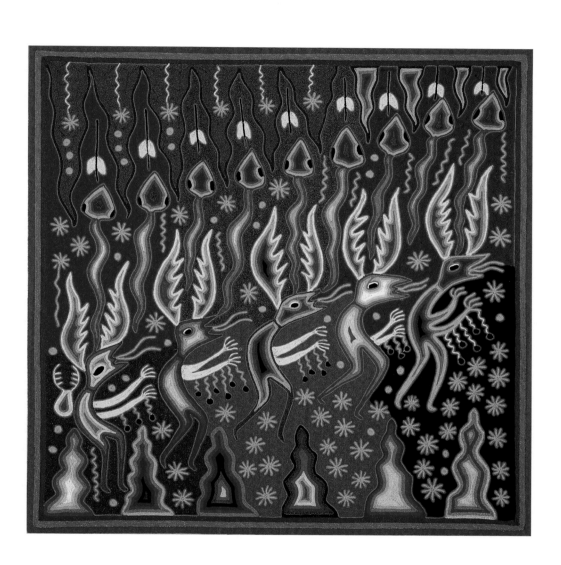

For the devout Huichol the peyote pilgrimage and the rituals that precede and follow it are central to spiritual life. In this nieríka a diagonal band of mythical creatures, sacred fires, and the knotted cord that symbolizes the *peyoteros* divides, but does not separate, a procession of women whose antlers identify them as goddesses. They are led by an antlered deer shaman holding his power wands. The culture hero, the divine Deer Person Káuyumari (above right), gives guidance as messenger beween the deities and the people. At lower left, sacred deer/peyote run beneath a star-studded night sky.

24 in. by 24 in. 97-15-28

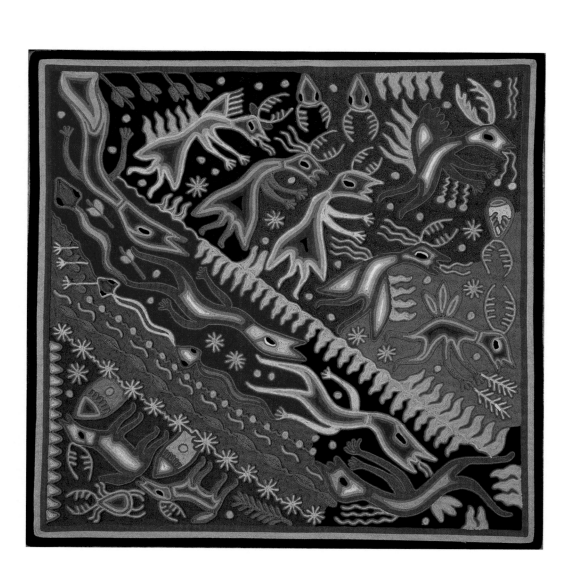

 A Huichol would need no more than footprints encircling a peyote cactus to imagine a whole ceremonial sequence on the peyote pilgramage: *peyoteros* forming the sacred circle, the search in the desert for the deer/peyote, veneration of the sacred cactus, the sacramental peyote meal, the slap of sandals on the desert floor to call the ancestors to join them, and at the end, the tearful farewell dance.

16 in. by 16 in. 97-15-26

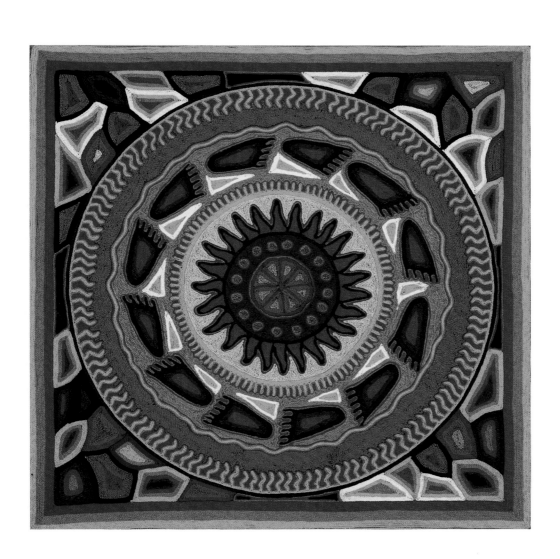

This nieríka represents the sacred circle of deer and peyote.
12 in. by 12 in. 97-15-9

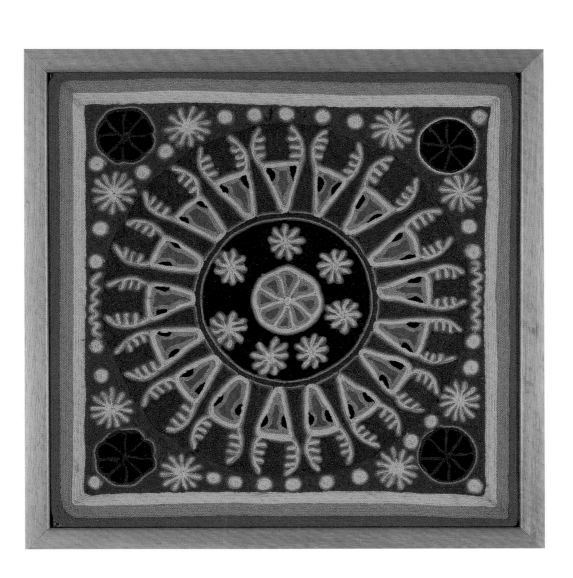

Any attempt to reproduce the myriad fleeting experiences of a peyote vision can only be a poor approximation. The apparitions and sensations of form, light, and sound literally tumble over each other, changing and passing in and out of the field of vision and even memory so instaneously that there is simply no way to convey even a semblance of the actual experience. Deer appear and reappear, as themselves or as their alter ego, the peyote; prayer arrows and souls of ancestors made manifest as luminous insects flash through the air; rain serpents streak across the starry sky from all sides to a sacred center, the heart of the world which is the peyote.

120 in. by 120 in. 97-15-29

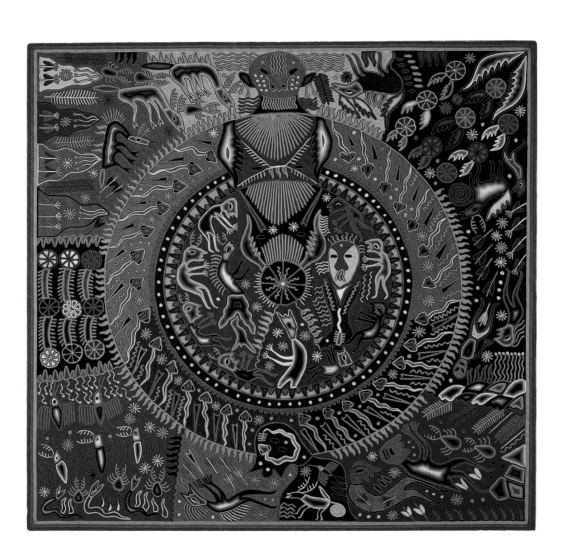

 In one of his smaller visionary yarn paintings, Benítez imagines how strange the Sun God would have looked to the ancestors when he first appeared in the world in a fiery eruption near the sacred peyote desert of Wirikúta.
16 in. by 16 in. 97-15-6

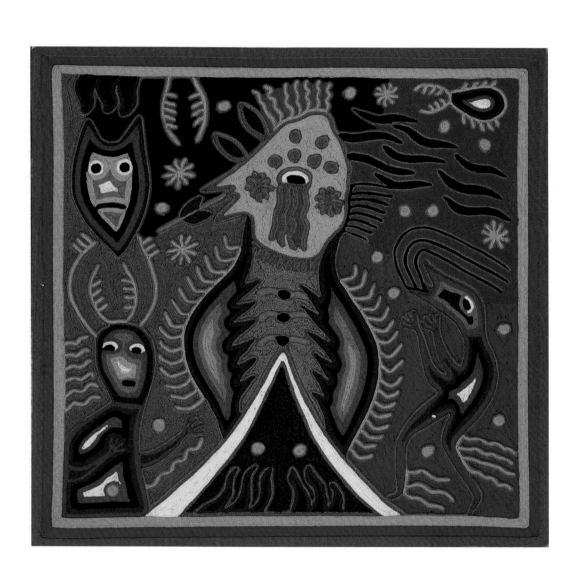

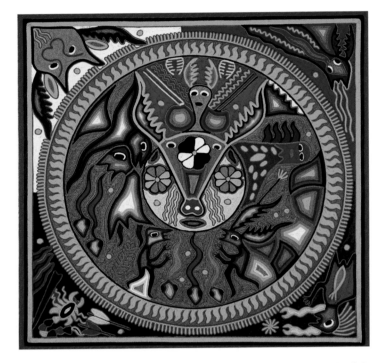

24 in. by 24 in. 97-15-2

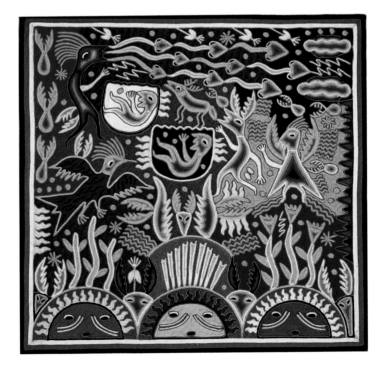

24 in. by 24 in. 97-15-16

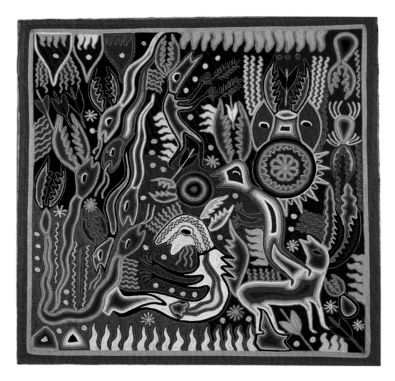

24 in. by 24 in. 97-15-17

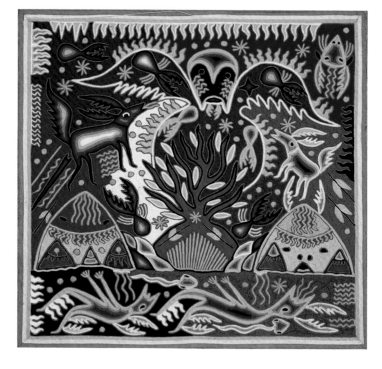

24 in. by 24 in. 97-15-18

"There was a dream where the sacred deer, the deer that is both a person and the peyote, came in many forms, as many animals with antlers on their heads and on their backs, and as the peyote. Even as a deer connected to the *takwátsi*, the basket that is also Káuyumari, in which the shaman keeps his sacred arrows [upper left]." —*José Benítez Sánchez*

32 in. by 24 in. 97-15-19

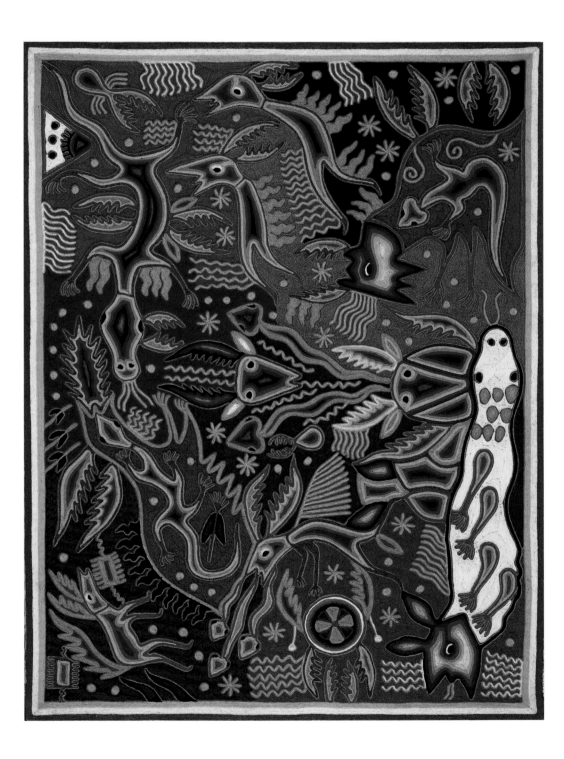

To ascribe specific meanings to the fleeting imagery of a peyote vision beyond what may be obvious is treading on uncertain ground, because visions come unbidden and race each other at such speed they would be impossible to recall, much less reproduce.

48 in. by 32 in. 97-15-13

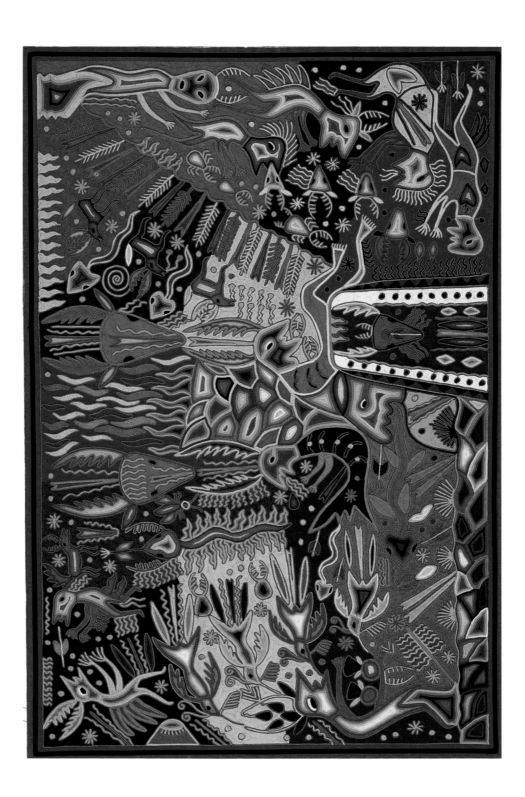

All life, some with form, others as yet without, began in the watery underworld, the great cosmic ocean presided over by Our Mother Haramara. Already in that earlier world—when the divine ancestors established Huichol lifeways—the concept of the divine peyote cactus and of the Deer that would be its alter ego in the animal world was present.

24 in. by 16 in. 97-15-23

It is impossible to overstate the importance and symbolic role of the deer hunt in Huichol religion. Deer is peyote and vice versa, and both are maize, the sacred food. In Benítez's vision, five hunters face the sacred deer, their own sacred status symbolized by the antlers sprouting from their leader's legs. Above and below, rows of feathered arrows are stuck into the ground, where they transform into magical messengers to the master of the deer species and the ancestor deities. At upper right is the woman who by ancient custom will place sacred foods and drink by the slain deer's mouth to feed and placate its soul. At lower left is the old fire god, whom Huichols call Tatewarí, Grandfather Fire.

32 in. by 24 in. 97-15-14

Beneath the disembodied eyes of the all-seeing sky goddess Our Mother Young Eagle Girl, a pair of antlered deer, one blue, the other white, attend to the great deer that presides over all the deer in Huichol cosmology. At lower right, Wirikúta is symbolized by mountains with human personalities and peyotes. The mountain at upper left with rain serpents below is matched at right by a doe whose breath of life turns into a rain serpent. 24 in. by 32 in. 97-15-5

"The first life emerges from the world ocean" is how Benítez explains this visionary nieríka.

32 in. by 24 in. 97-15-30

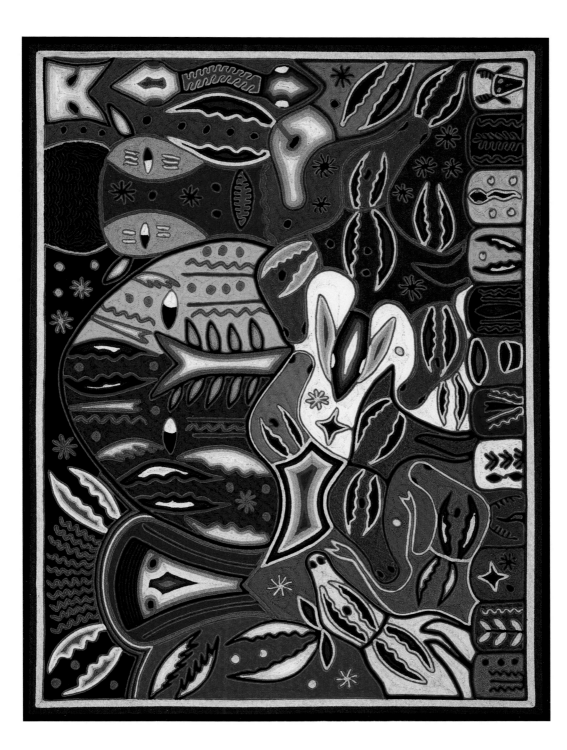

By its bright-green color, its matching pair of antlers, and the prayer arrow pointed at its heart, the little peyote cactus in the middle is central to this nierīka which is crowded with life forms and symbols. At the top a row of peyotes is crowned by antlers that mark them as sacred. Above and below the central peyote are two more, similarly embellished with prominent antlers. In the lower right corner is a flowering *kiéri*, a poisonous plant with a dual personality: sometimes a dangerous and highly toxic sorcerer and sometimes a teacher of esoteric arts. Right, a shaman with flowing hair and accompanied by rain serpents chases a purple deer with points of light at the tips of its antlers. On the left is a great nocturnal creature, and at the bottom, a pink blue-headed deer lying on its back with speech or song lines coming from its mouth.

43 in. by 32 in. 97-15-1

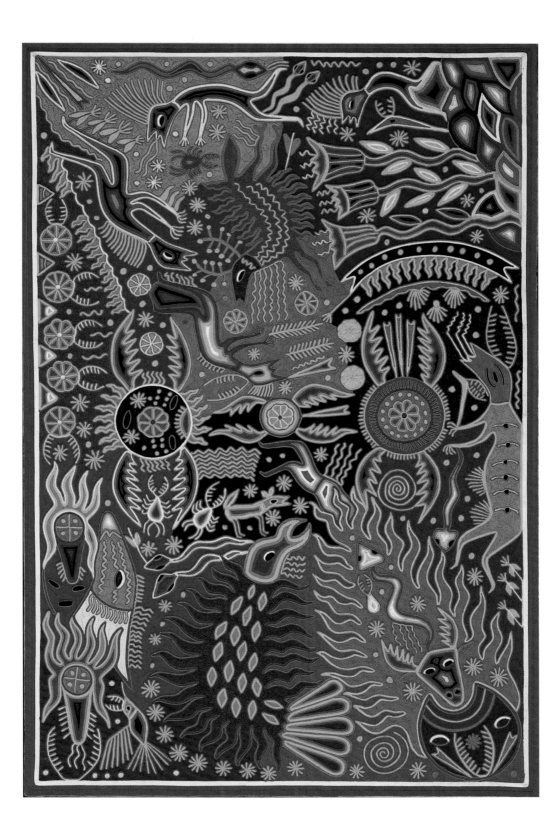

This magnificent rendering of a sacred vision brings to mind a 19th century description of a peyote vision "stars...delicate floating films of color...then an abrupt rush of countless points of white light swept across the field of view...the wonderful loveliness of swelling clouds of more vivid colours gone before I could name them...Then, for the first time, definite objects associated with colors appeared...green, purple, red, and orange....All the colors I ever beheld are dull compared to these" (Schleiffer 1973).

32 in. by 24 in. 97-15-20

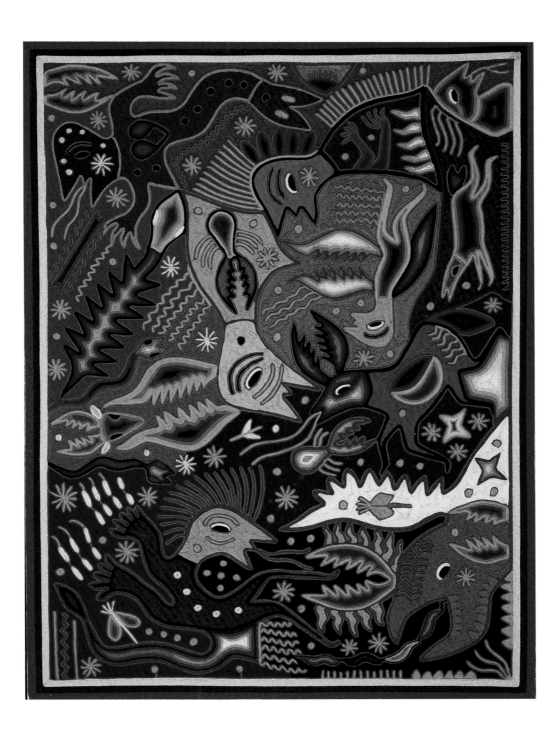

This nieríka depicts a shamanic song about how the Sun came into the world in a fiery volcanic explosion. At upper right is the Sun's underground path to the west, lined with prayer arrows and marked by footprints. At lower left, the Sun Father is resplendant in all his shining glory, sent into the sky by the aged Fire God and First Shaman, Grandfather Fire, and his chief assistant, the culture hero and Deer Person Káuyumari. The diagonal band from lower right to upper center is the Sun's path in the sky.

32 in. by 24 in. 97-15-25

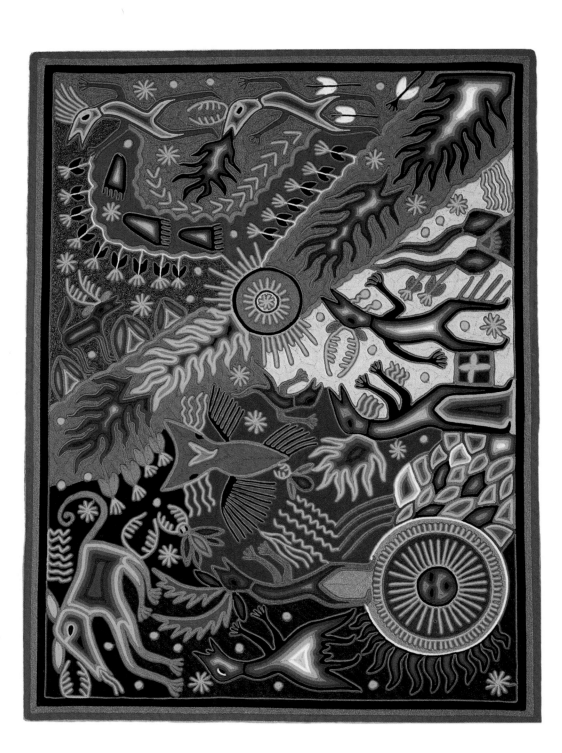

Through the complex chemistry of peyote Huichols make personal contact with the sacred: innumerable ancestor and nature deities and the myriad animating spirits of a natural environment. Benítez seeks to convey this in this mandala-like yarn painting. In the center circle, peyote is shown at the heart of the world and as the focus of the four cosmic directions. Antlered versions of peyote appear in each corner, encircled by animal guardians and sacred arrows.

32 in. by 24 in. 97-15-11

When Huichols call Wirikúta the most beautiful place in the world, it may be this kind of visionary experience of the peyote desert they have in mind.

48 in. by 32 in. 97-15-27

The aboriginal Huichol temple, called *tuki*, is sometimes oval instead of perfectly round. This may have inspired Benítez to visualize a primordial sequence of creation and transformation around a whirling double-headed cosmic serpent within the sacred space of an oval temple.

32 in. by 24 in. 97-15-22

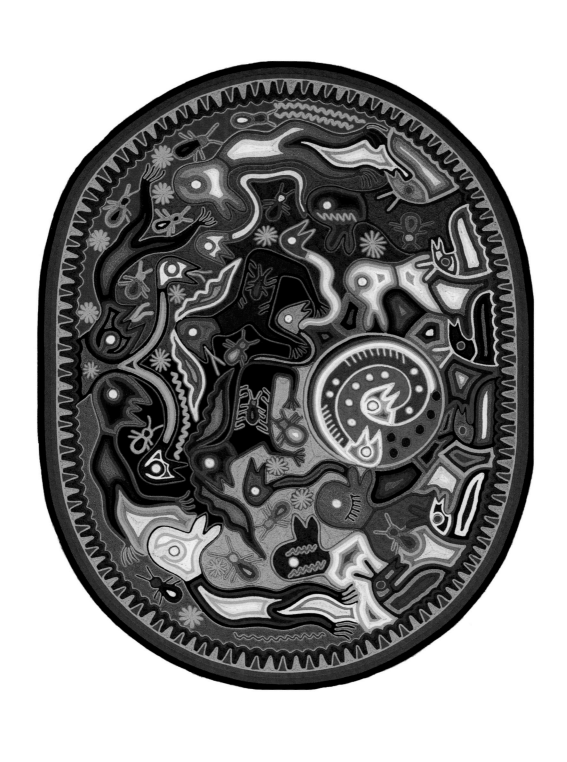

Readings

Anderson, Edward F.
 1996. *Peyote: The Divine Cactus*. 2d ed. Tucson, AZ: University of Arizona Press.

Benítez, Fernando
 1975. *In the Magic Land of Peyote*. Translated by John Upton. Austin, TX: University of Texas Press.

Bernstein, Susan, ed.
 1989. *Mirrors of the Gods: Proceedings of a Symposium on the Huichol Indians*. San Diego Museum of Man Papers No. 25. San Diego, CA.

Berrin, Kathleen, ed.
 1978. *Art of the Huichol Indians*. San Francisco and New York: The Art Museums of San Francisco and Harry N. Abrams.

Eliade, Mircea
 1964. *Shamanism: Archaic Techniques of Ecstasy*. Princeton, NJ: Princeton University Press.

Furst, Peter T.
 1976. *Hallucinogens and Culture*. Novato, CA: Chandler and Sharp.

 1994. "The *Mara'akáme* Does and Undoes: Persistence and Change in Huichol Shamanism." In *Ancient Traditions: Shamanism in Central Asia and the Americas*, ed. Gary Seaman and Jane S. Day, pp. 113–177. Denver, CO: Denver Museum of Natural History and University Press of Colorado.

Furst, Peter T., ed.
 1972. *Flesh of the Gods: The Ritual Use of Hallucinogens*. New York: Praeger. New ed. Prospect Heights, IL: Waveland Press, 1990.

Huxley, Aldous
 1954. *The Doors to Perception*. New York: Harper.

Lumholtz, Carl
 1900. *Symbolism of the Huichol Indians*. New York: Memoirs of the American Museum of Natural History 3. New York.

1902. *Unknown Mexico*. 2 vols. New York: Scribner's.

1904. *Decorative Art of the Huichol Indians*. Memoirs of the American Museum of Natural History 3, no. 3. New York.

MacLean, Hope
2001a. "The Origins of Huichol Yarn Painting." *American Indian Art Magazine* 26(3): 42–53.

2001b. "The Origins of Huichol Yarn Painting, Part II: Styles, Themes, and Artists." *American Indian Art Magazine* 26(4): 68–77, 98–99.

Myerhoff, Barbara G.
1974. *Peyote Hunt: The Sacred Journey of the Huichol Indians*. Ithaca, NY: Cornell University Press.

Schaefer, Stacy B.
2002. *To Think with a Good Heart: Wixárika Women, Weavers, and Shamans*. Salt Lake City, UT: University of Utah Press.

Schaefer, Stacy B., and Peter T. Furst, eds.
1996. *People of the Peyote: Huichol Indian History, Religion, and Survival*. Albuquerque, NM: University of New Mexico Press.

Schleiffer, Hedwig, comp.
1973. *Sacred Narcotic Plants of the New World Indians: An Anthology of Texts from the 16th Century to Date*, pp. 32–44. New York: Hafner Press.

Index

About the Author

After receiving his Ph.D. in Anthropology at the University of California at Los Angeles in 1966, Peter T. Furst served as Associate Director of the UCLA Latin American Center until 1971, when he was appointed Professor of Anthropology and Latin American Studies and Department Chair at the State University of New York at Albany. From 1972 until 1987 he was also a Research Associate of Harvard University's Botanical Museum. In 1987 he joined the research staff of the University of Pennsylvania Museum of Archaeology and Anthropology. He is also currently a Research Associate of the Museum of Indian Arts and Culture/Laboratory of Anthropology, in Santa Fe, New Mexico.

Dr. Furst has done field work in Venezuela among the Warao Indians, in Mexico among the Huichols, and throughout Mesoamerica in Precolumbian art and archaeology, religion, and shamanism. In 1964 he curated the first exhibition in the United States of Precolumbian gold, and in 1968 the first exhibition of Huichol yarn art, both at the Los Angeles County Museum of Natural History. He is author of more than 120 books and scholarly articles, including many on Huichol art, religion, and mythology.